ESSEX
THROUGH TIME
Michael Foley

AMBERLEY

Acknowledgements

To Lucas, Liam's best friend.

I would like to thank Footsteps Photos at www.footstepsphotos.co.uk for providing some the old images on pages 24, 38, 39, 40, 41, 48 and 54. I would also like to thank Alan Filtness for helping me to find some of the places in the book.

www.mike-foley-history-writer.co.uk

Bibliography

Havering Through Time
Barking and Dagenham Through Time
London Through Time
East End of Lodon Through Time
Essex at War Through Time
Essex at War From Old Photographs

First published in 2012 by
Amberley Publishing for Bradwell Books

Amberley Publishing
The Hill, Stroud
Gloucestershire, GL5 4EP
www.amberley-books.com

Copyright © Michael Foley, 2012

The right of Michael Foley to be identified as the
Author of this work has been asserted in accordance
with the Copyrights, Designs and Patents Act 1988.

ISBN 978 1 4456 0991 1

British Library Cataloguing in Publication Data.
A catalogue record for this book is available from
the British Library.

Typeset in 9.5pt on 12pt Celeste.
Typesetting by Amberley Publishing.
Printed in the UK.

Introduction

Essex is a county of contrasts. The west of the county is now seen as part of London with the London Boroughs of Barking and Dagenham, Redbridge and Havering actually positioned in Essex but almost indistinguishable from the rest of East London. Moving to the east, however, things are very different. Once past the end of the London Underground district line at Upminster, the county becomes much more rural. Many of the towns in the county have grown from small villages with the addition of more modern housing.

In many of these towns a small area of the old village survives, usually based round an old church. Many of the small villages have survived independently and stand alone surrounded by open countryside. It is not too difficult to find the odd thatched cottage or weather boarded house among the old buildings. Further east the coastal towns of the county are well known as seaside holiday destinations. Although some, despite owning a sea title, actually stand on the River Thames, which flows along the southern edge of the county and gives Essex a strong sea going identity.

Once, all the ships that sailed to one of the world's busiest ports in the city of London passed the Essex coast. Now that the port of London has declined, it was only fitting that its waterborne trade should have moved downriver to Tilbury; and, of course, apart from the busy docks, there is also a ferry terminal at Parkstone near Harwich, where regular ferries cross to Europe, and an international airport at Stanstead. Apart from the modern amenities all connected by ample road and rail links, the county has wonderful countryside, a rich history and shopping centres comparable to any in the country.

Hopefully this book will inform you about the county if you don't know it, or remind you of some places you may have forgotten about if you do. Setting the book out alphabetically didn't seem to make much sense so I have set it from the west going towards the coast.

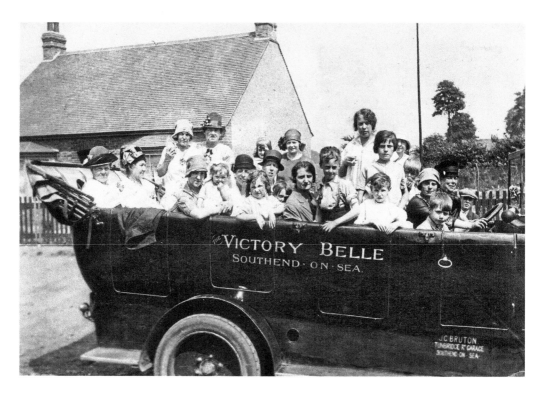

Southend

Southend has always been a popular venue for a day out for folk from Essex and London as this old open-topped vehicle shows. Not all trippers to the seaside got there by road. Some took the old steamships that sailed along the Thames from London to dock at the end of Southend pier.

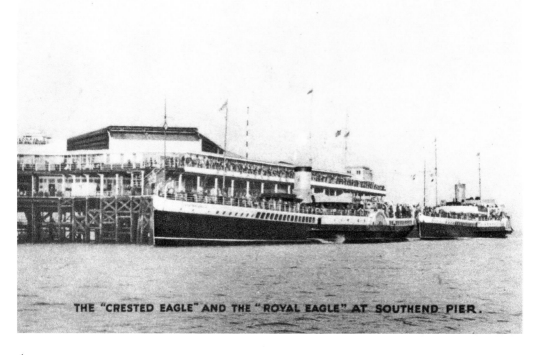

THE "CRESTED EAGLE" AND THE "ROYAL EAGLE" AT SOUTHEND PIER.

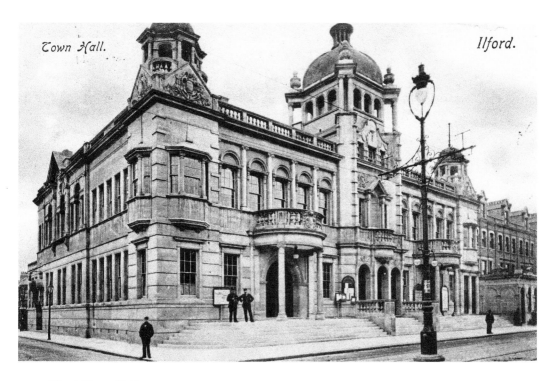

Town Hall. *Ilford.*

Ilford, Town Hall

The town hall opened in 1901. What is now the main hall was once the original council chamber. Although the front of the building once stood on the High Road, this is now part of the pedestrianised shopping centre.

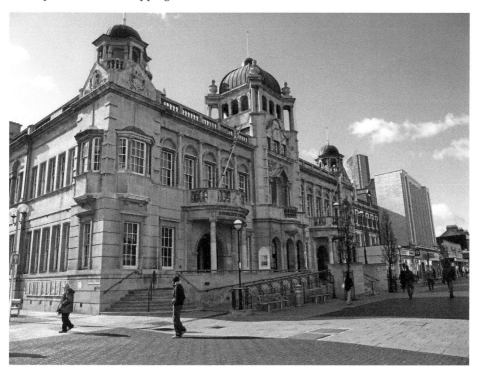

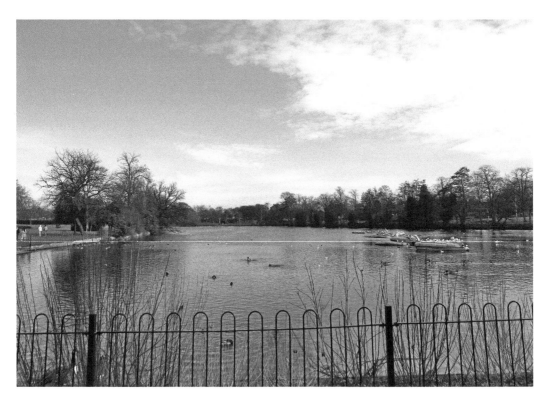

Ilford, Valentines Park

The park was once the grounds of Valentines Mansion built in 1696. It was one of the estates owned by Sir Charles Raymond. In 1912 it became a public park and has retained many of the original features such as the lake.

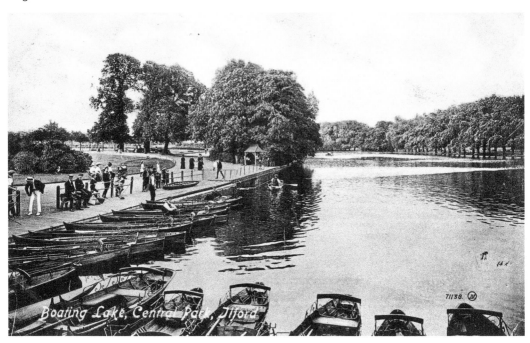

Boating Lake, Central Park, Ilford

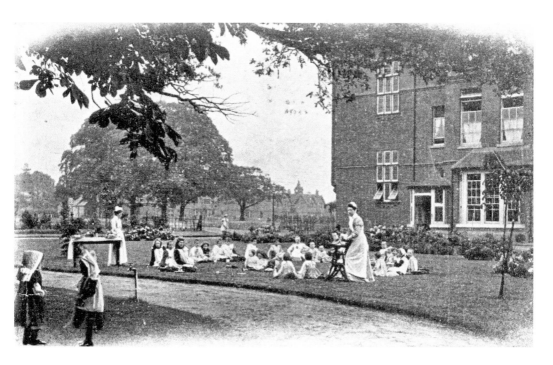

Barkingside, Barnado's

The Girl's Village Home opened in the late nineteenth century. It was built so that each house was a separate part of the village. It closed in 1986 and the buildings have been turned into housing association flats. There is now a large office building for Barnado's on the site.

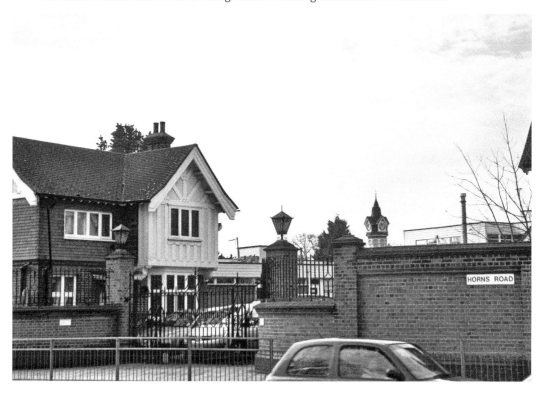

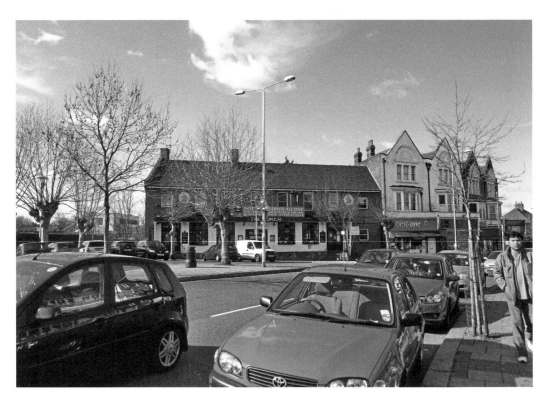

Seven Kings, Seven Kings Hotel

The old building in the photograph shows a different one to the modern photograph. At some time in the past the hotel was rebuilt. It also acquired the name 'Joker' at one point.

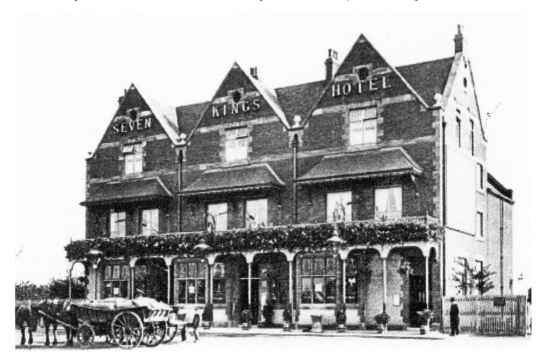

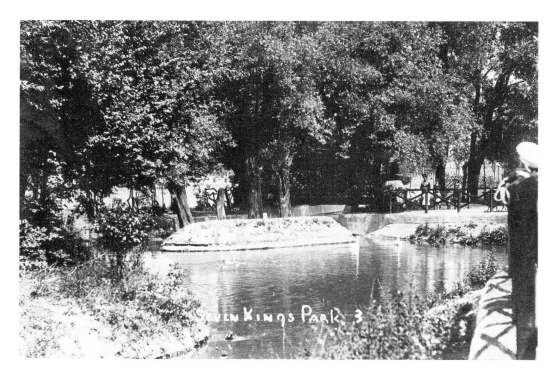

Seven Kings, The Park

The old image of the park shows the Edwardian grandeur of parks of the period. The park has changed greatly now and as the modern image shows, the type of amusements that today's users have are very different.

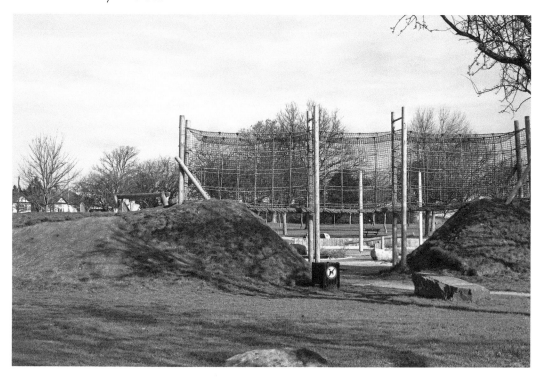

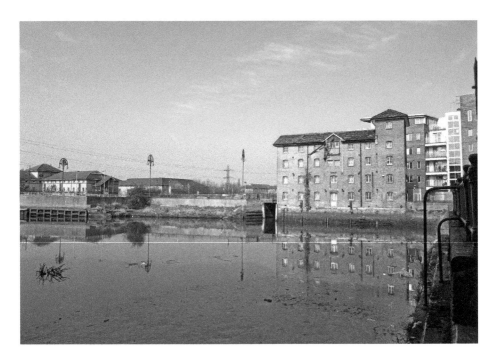

Barking, Town Quay

The town quay was the site of Barking's biggest industry until the nineteenth century. A large fleet of fishing vessels sailed from the creek. The fleet eventually moved to Yarmouth and other industries grew around the quay using the river to transport goods. The modern photograph shows that the quay is now surrounded by flats.

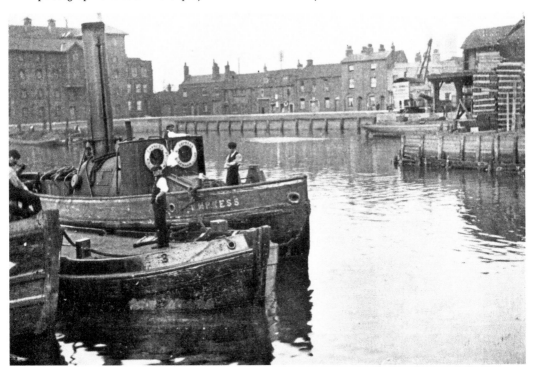

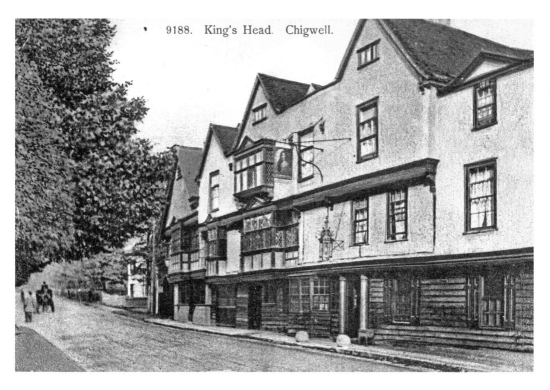

9188. King's Head. Chigwell.

Chigwell, King's Head

The Old King's Head is in Chigwell Village and was once a coaching inn. It is thought to be the Maypole in Charles Dickens's book *Barnaby Rudge*. The building is no longer a public house, but is now a restaurant.

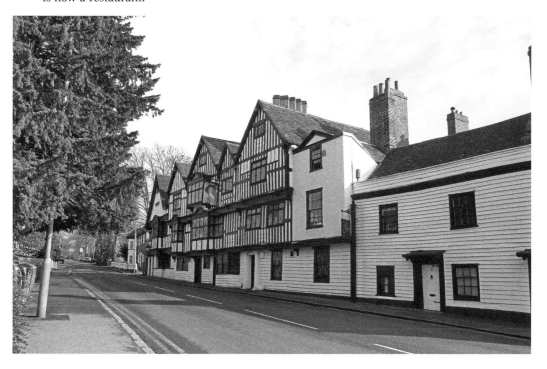

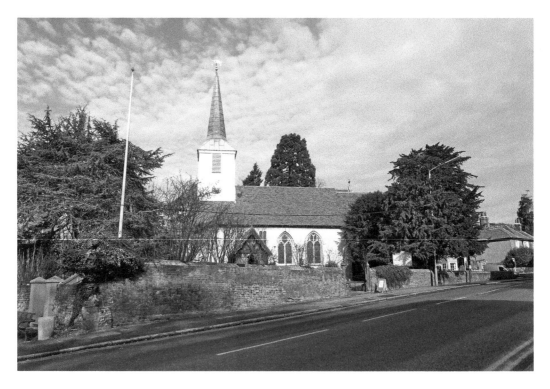

Chigwell, St Mary's Church

St Mary's church in Chigwell Village is over 800 years old. Along with the Old King's Head and a few other buildings, it is part of what was originally the Old Village. A few hundred yards along the road a large town has grown around the railway station with many more modern buildings than those around the church.

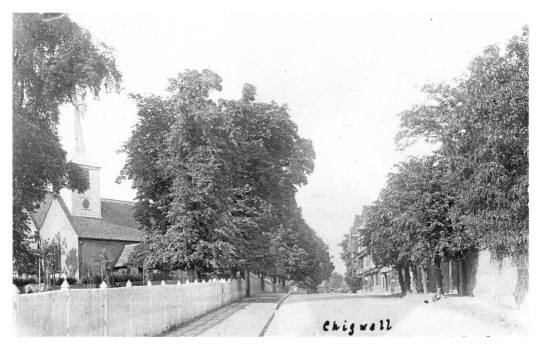

Chigwell

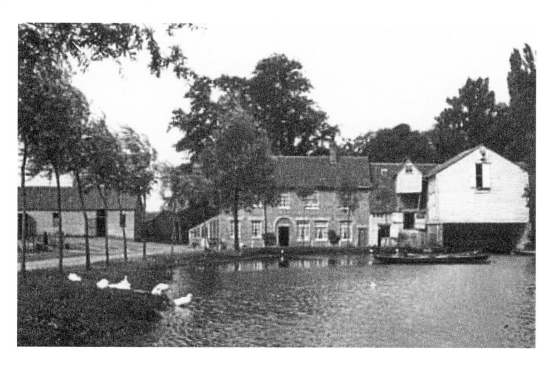

Harlow, The Mill

The old photograph shows Harlow Mill on the River Stort. The railway station nearby opened in 1842 to serve Harlow Village. In 1960 the station was renamed Harlow Mill after the nearby mill. The modern photograph shows the more up-to-date Harlow Mill.

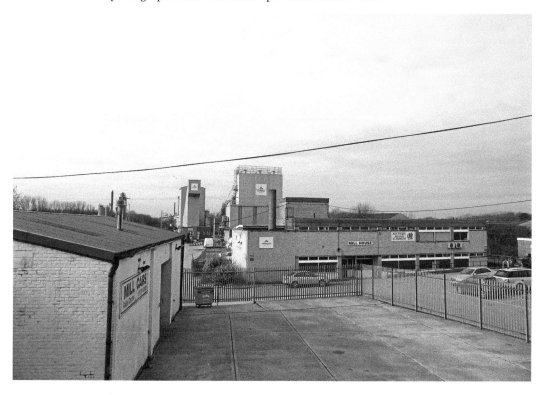

13

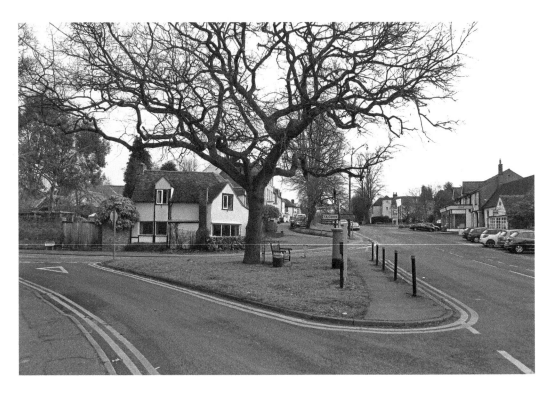

Harlow, The Green

The Green is in Old Harlow. The village pre-dates the Norman Conquest. It is now known as Old Harlow since the new town was built nearby. The area still preserves much of its historical atmosphere with some lovely old buildings.

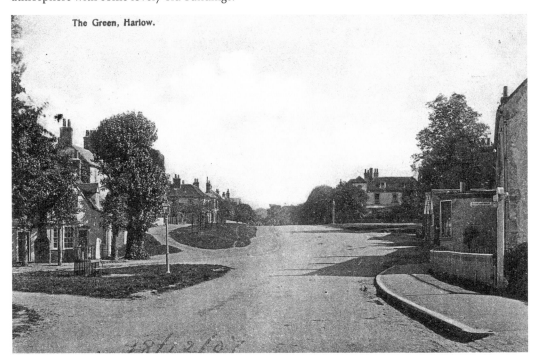

The Green, Harlow.

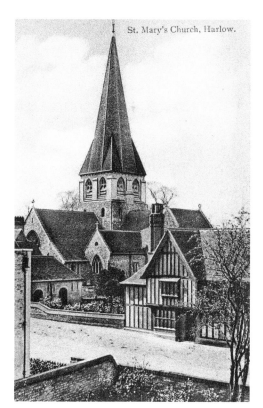

St. Mary's Church, Harlow.

Harlow, St Mary's Church

There has been a church on the site of
St Mary's since at least the twelfth century.
Much of the present building dates from
the fifteenth century. One of the six bells in
the tower dates from 1613. As the modern
photograph shows the church is still
surrounded by some very old buildings.

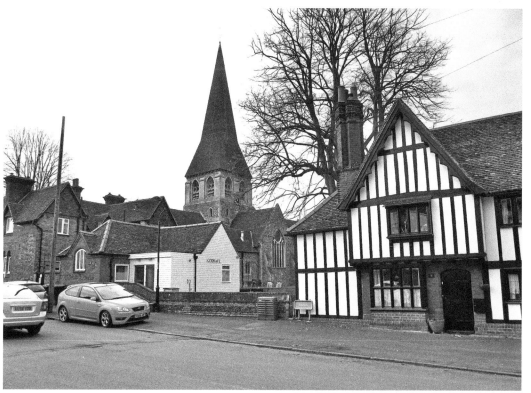

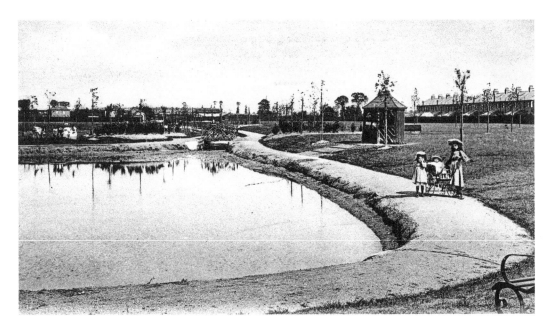

Goodmayes, The Park

The park was opened in 1905, around the time when many of the local houses were built. In typical Edwardian fashion it had a bandstand and a boating lake, neither of which are still there. The lake has survived however and is a home for various wildlife.

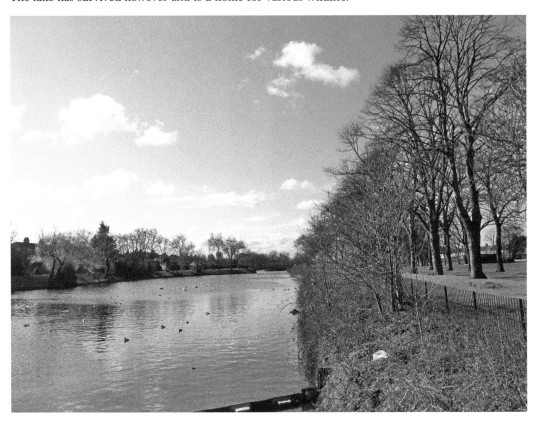

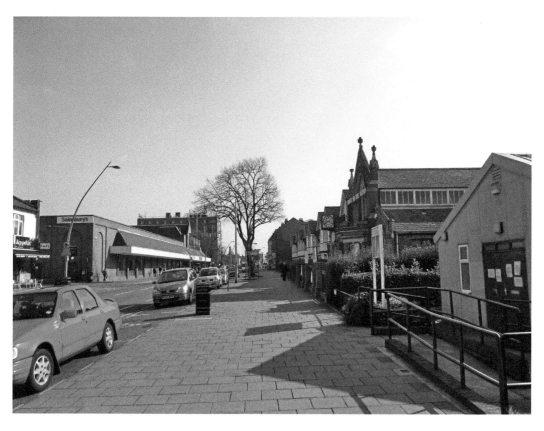

Chadwell Heath, High Road

The High Road follows the route of the old Roman road from London to Colchester. Chadwell heath was a small village separate from Barking and Dagenham of which it is now part. It was once the final stop for trams from London.

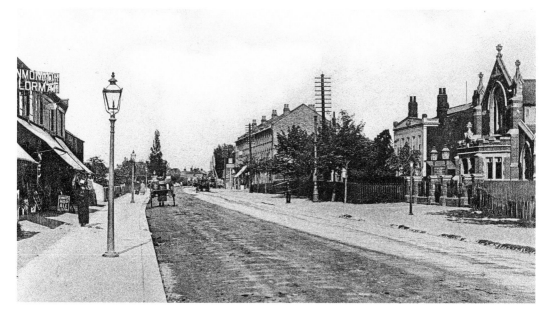

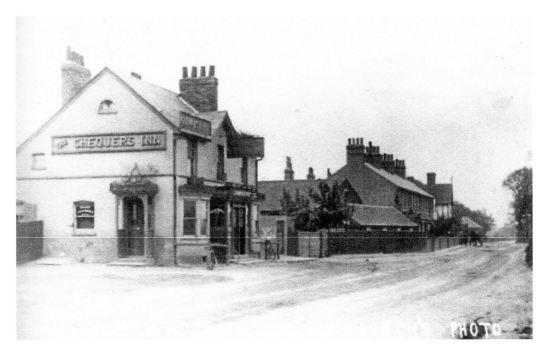

Dagenham, The Chequers

The Chequers public house in Dagenham stood on the corner of Chequers Lane. It was once a country inn and was often the site of visits from groups from the east end of London. The area around the building has a varied history. An early flying ground once stood close by before Ford Motor Company took over much of the surrounding area. The pub was later demolished and a retail park now stands on the site.

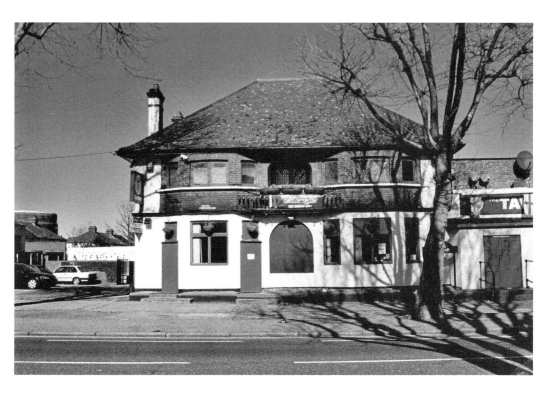

Rush Green, The Havering Well

A public house has stood on the site of the Havering Well for many years. The area of Rush Green was once a small rural village and has now been engulfed in both Romford and Dagenham. The pub's name has changed on a number of occasions including the Coopers Arms, the Rush Green Tavern and now the Havering Well.

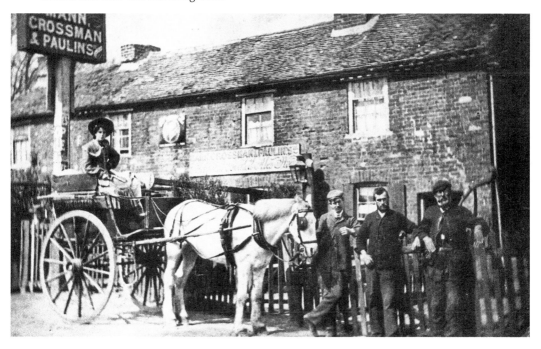

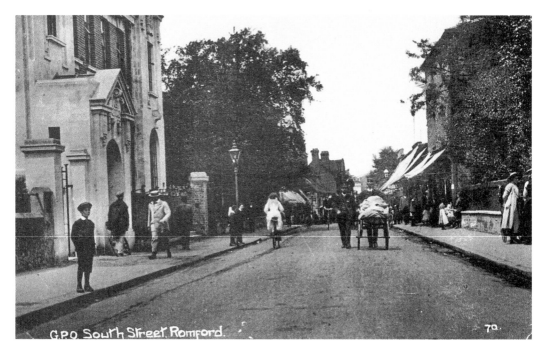

G.P.O. South Street. Romford. 7a.

Romford, The Post Office

Romford has been a busy market town for a great many years. The Post Office stood in South Street and was still in use up to the 1960s. Since then many of the older buildings in the town have vanished. The Post Office survived but is now a nightclub. The top floor however still has some original features.

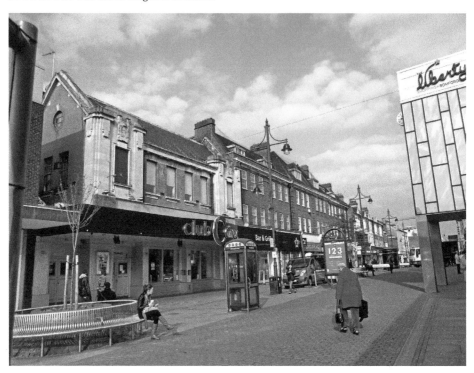

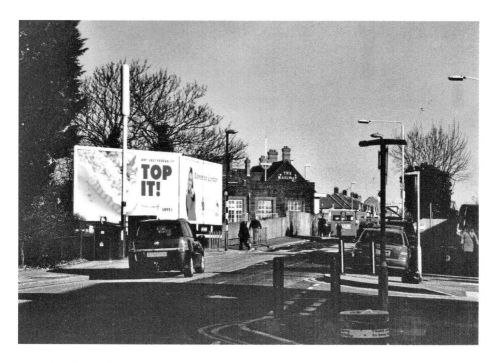

Hornchurch, Station Lane

Station Lane leads from Hornchurch town centre to the station. Once past the station it becomes Sutton's Lane. As the old image shows it was once very rural, and although it has now been built on around the station, a large area that was once RAF Hornchurch is still open countryside just along Sutton's Lane.

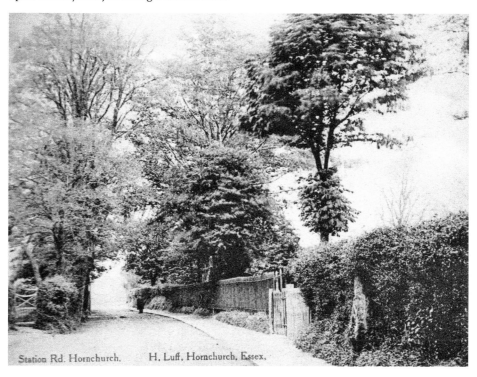

Station Rd. Hornchurch. H. Luff, Hornchurch, Essex,

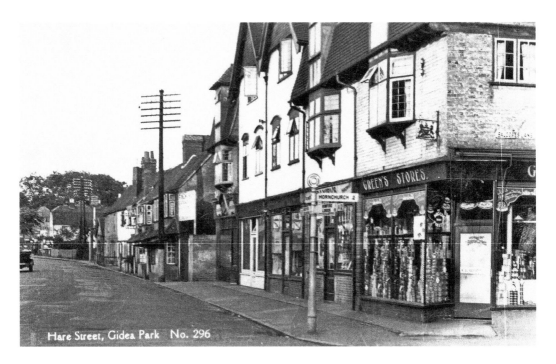

Hare Street, Gidea Park No. 296

Gidea Park, Hare Street

Hare Street was once a quiet little hamlet close to Romford. It was once the home of the famous gardener Humphrey Repton. During the First World War the area was the site of a large army camp. It was around this time that the area was built on and spread out to join with nearby Romford.

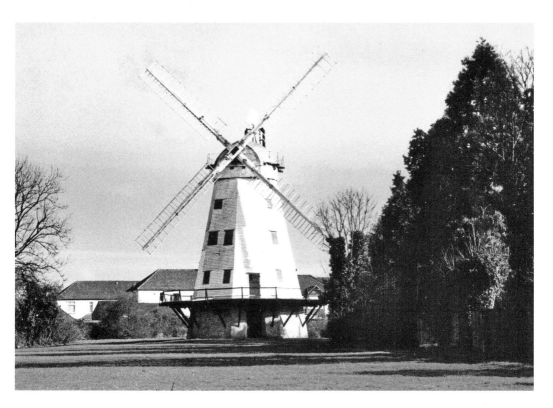

Upminster, The Windmill

The windmill was built by a local farmer in 1803. It continued to grind flour until 1910 and animal feed until 1934. It then became derelict. It was repaired in 1960 by the Council and opened to the public, and since 1967 it has been run by volunteers.

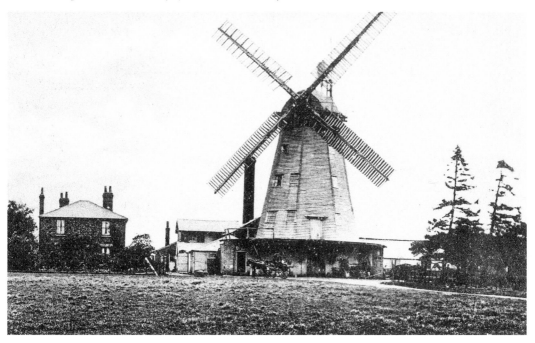

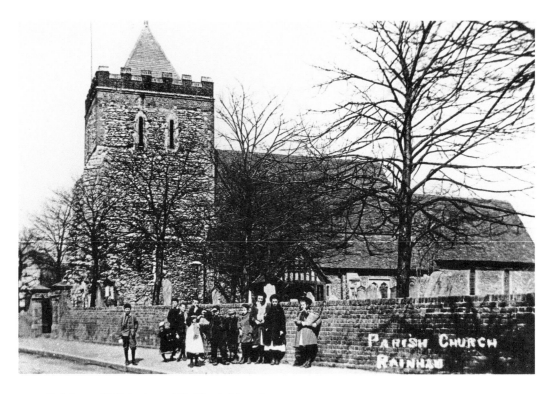

Rainham, St Helen's and St Giles's Church

The church of St Helen's and St Giles' is the oldest in Havering. It was built between 1160 and 1170 by Richard De Lucy, the son-in-law of Henry II, and still retains many of its original features.

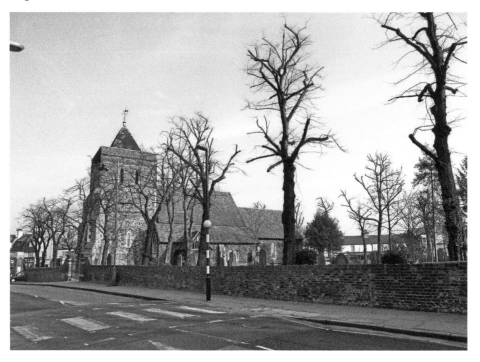

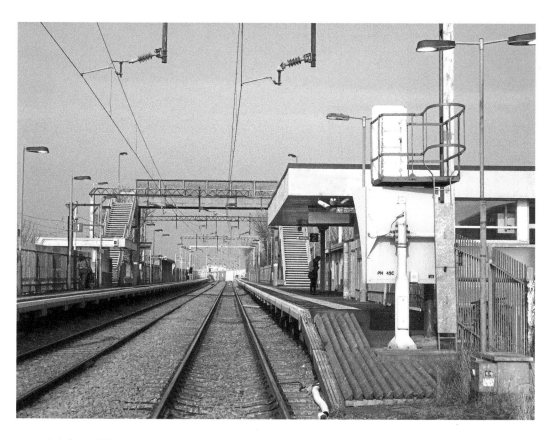

Rainham, The Station

The station opened in 1898 and changed little for many years. It stands at the entrance to Ferry Lane and once overlooked Purfleet Rifle Ranges that lined the lane. The level crossing that stood for many years at the entrance to Ferry Lane is now closed to traffic as the high speed Channel Tunnel Rail Link now runs alongside the station and can only be crossed by footbridge.

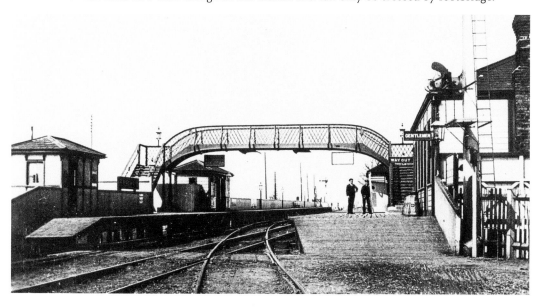

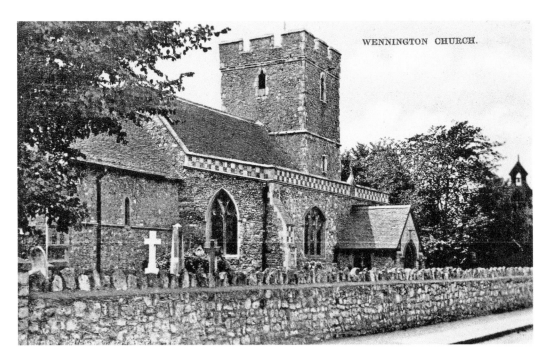

WENNINGTON CHURCH.

Wennington, St Mary and St Peter's Church

There was a church on the site of the present church as early as 1042 when it was owned by Westminster Abbey although the population of the village in 1066 was only eight. The present church of St Mary and St Peter was built in the thirteenth century and has been added to since. The village preserves its separate identity today and the population has always been in the hundreds.

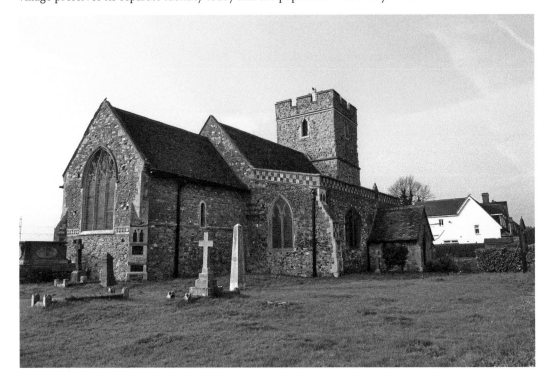

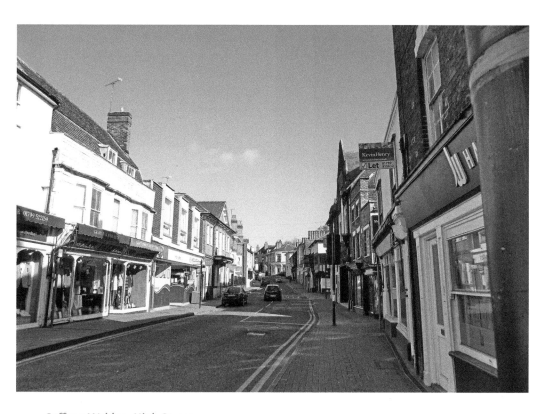

Saffron Walden, High Street

Saffron Walden has been a settlement since the Roman era and was a Saxon town after they left. The High Street is like the rest of the centre of the town and has a number of interesting old buildings along with a few more modern ones.

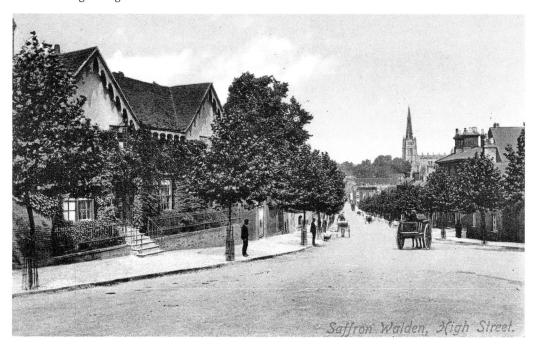

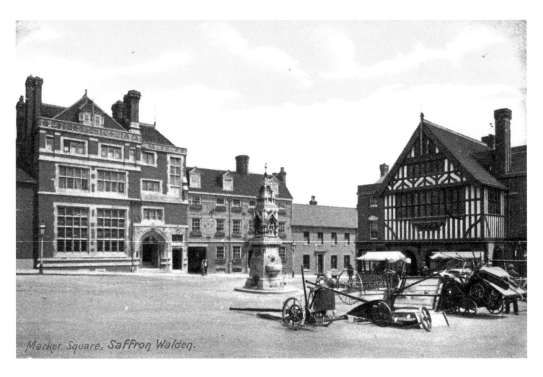

Market Square, Saffron Walden.

Saffron Walden, The Market

The market place in Saffron Walden has obviously changed very little in the recent past. There has been a market in the town since 1141 when it was transferred from Newport. The buildings around the square include the Town Hall and the Corn Exchange, now the Library.

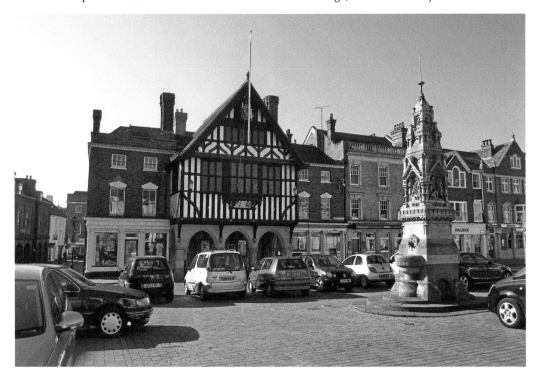

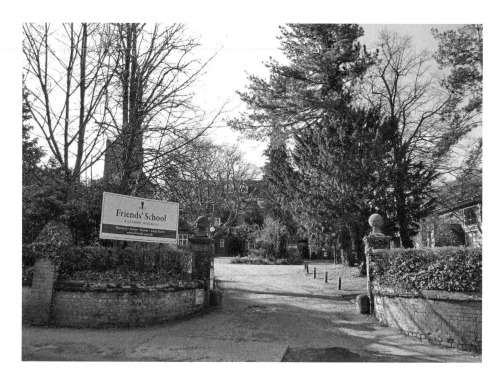

Saffron Walden, The Friend's School

The Friend's School is an independent Quaker school for boys and girls aged three to eighteen. The school was set up initially in London and was based on three sites, the last being Croydon where typhoid broke out in the 1870s. It was decided the school should move outside London to the healthier site at Saffron Walden, which opened in 1879.

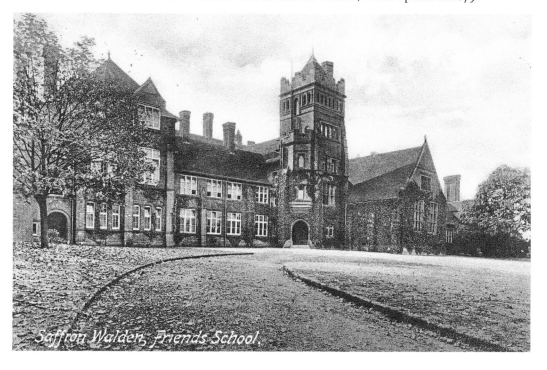

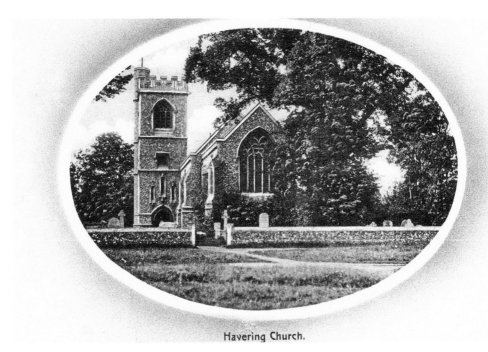

Havering Church.

Havering Atte Bower, St John's Church

Despite the fact that the village of Havering has an ancient history, once being the site of a royal palace, the church of St John that stands on The Green only dates from 1875. The old stocks and whipping post also stand on The Green in view of the church.

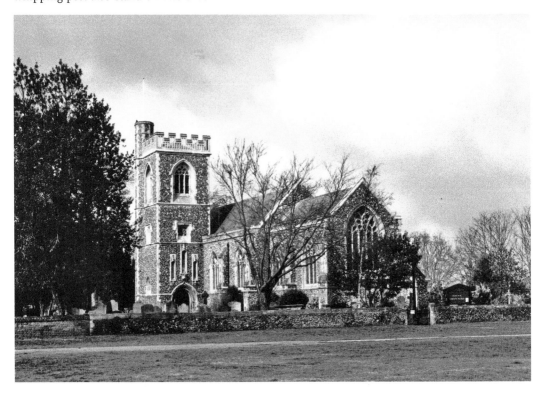

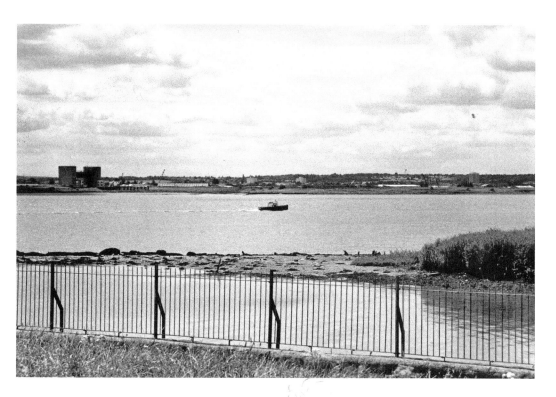

Purfleet, the *Cornwall* Training Ship

There were several training ships for boys on the Thames around the turn of the twentieth century. The *Cornwall* was moored off Purfleet. It was the scene of a disaster during the First World War when a boat from the ship was run down in the river and several of the boys drowned.

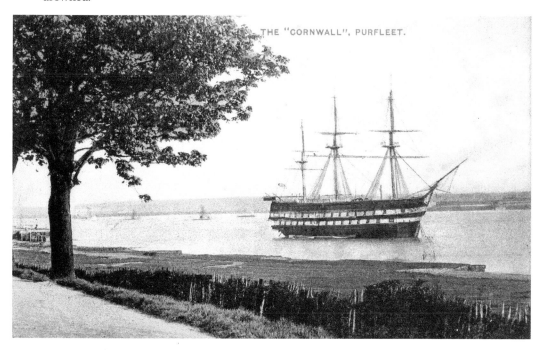

THE "CORNWALL", PURFLEET.

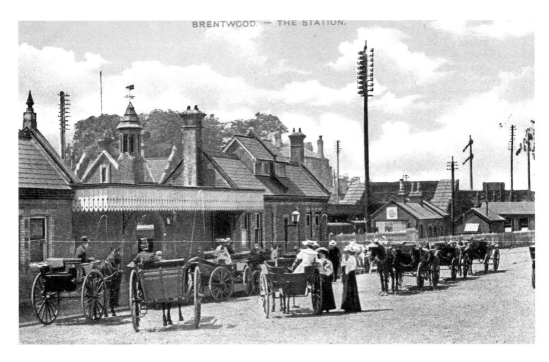

Brentwood, The Station

The railway station in Brentwood opened in 1840 and was the temporary terminus of the Eastern Counties Railway Company. The line was extended to Colchester in 1843. In 1850 a group of twenty-five workers on the railway were struck by a train leading to nine deaths.

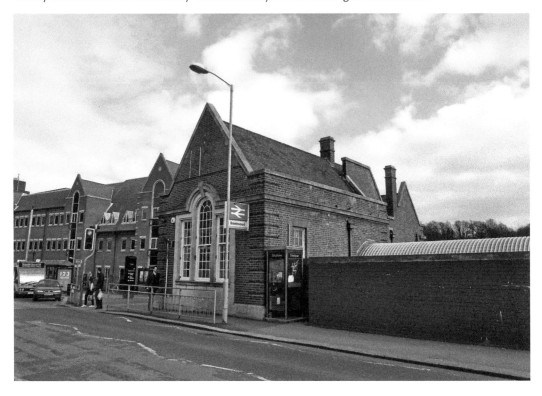

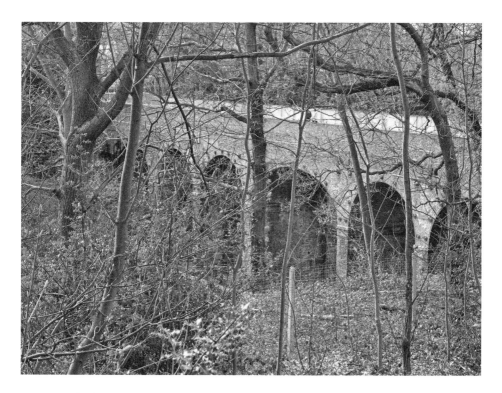

Brentwood, The Seven Arch Bridge

The bridge is one of several which span the line out into Essex but few have so many spans. The road that runs across the bridge is named after it. Bridges were normally a good spot for watching steam trains in the past. Because of the steep gradient up to Shenfield, trains passing under the bridge would be on full power and throw out lots of smoke and cinders.

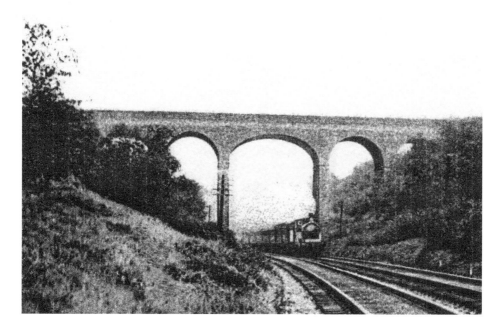

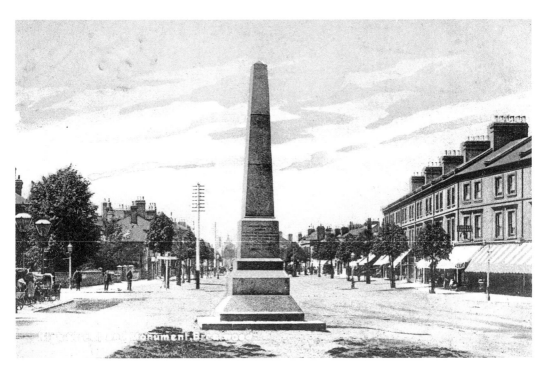

Brentwood, The Hunter Monument

The monument of William Hunter was raised in 1861. Hunter was a Protestant in the reign of Mary Tudor. He lost his job for refusing to go to Catholic mass. He was then found reading the Bible in Brentwood Chapel. Then he was sent before Bishop Bonner and burnt at the stake at Brentwood in 1555.

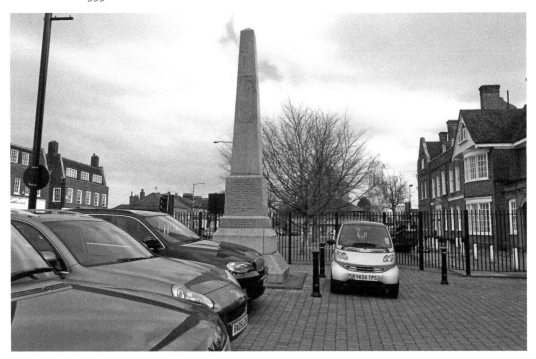

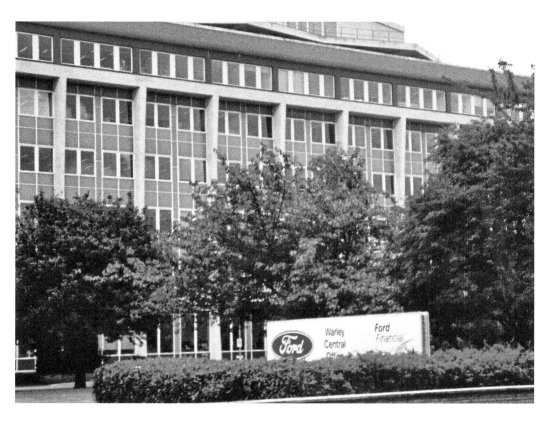

Warley, The Barracks

Warley was the site of a number of large military camps from the eighteenth century. This developed into barracks in the nineteenth century. They were occupied by the army of the East India Company for some time then became the home of the Essex Regiment. Few of the buildings survive, the site now being part of Ford Motor Company.

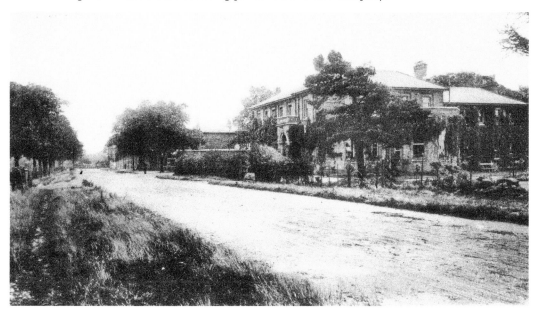

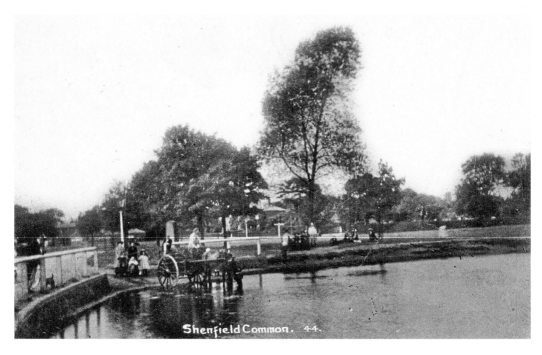

Shenfield Common. 44.

Shenfield, The Common

The common was owned by a number of landowners before becoming a public park in 1881. An avenue of lime trees was planted in 1895 to give the unemployed work. A bandstand once stood on the site and was used by bands from Warley Barracks. The pond has changed little although few horses drink from it now.

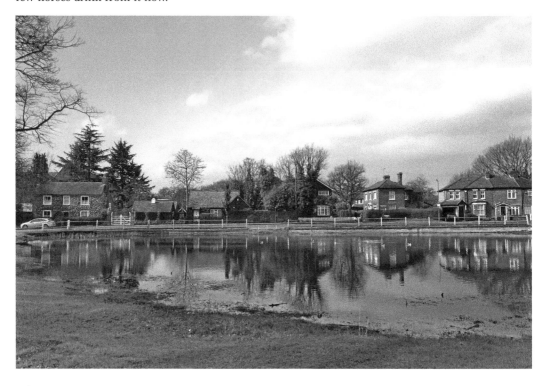

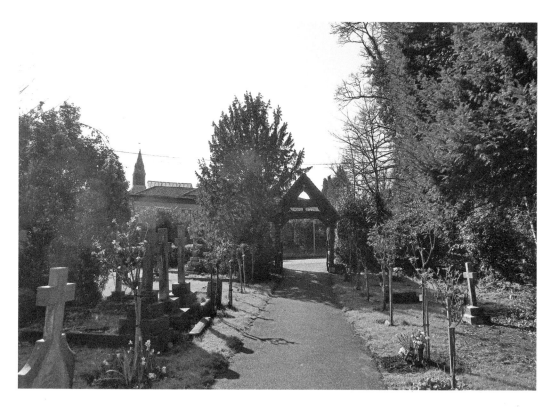

Shenfield, St Mary's Lych Gate

The gate is the entrance to St Mary's church in what is now Old Shenfield situated in Hall Lane which has changed little. The modern town has been built around the station which is near Hutton. The tower is part of St Mary's Primary School.

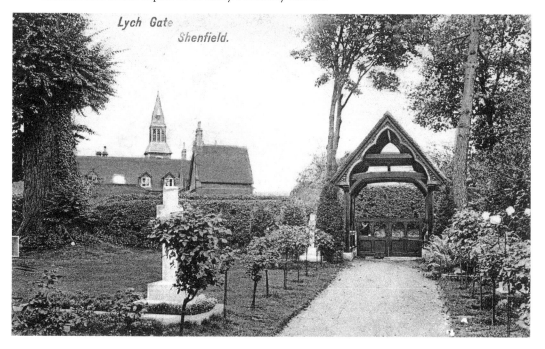

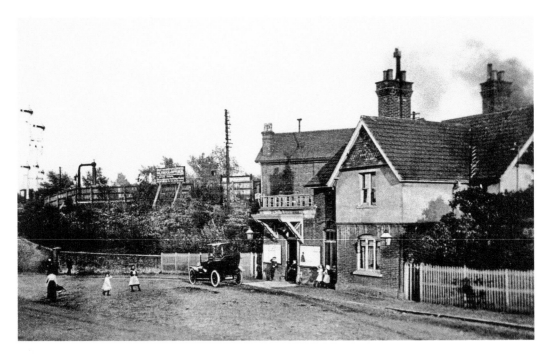

Shenfield, The Station

The station opened in 1843, but the cutting was so difficult between Brentwood and Shenfield that it held up the line to Colchester. It then closed in 1850 due to lack of use. It reopened in 1887 as Shenfield and Hutton Station. The station has been updated over time until it is barely recognisable from the image from the early twentieth century.

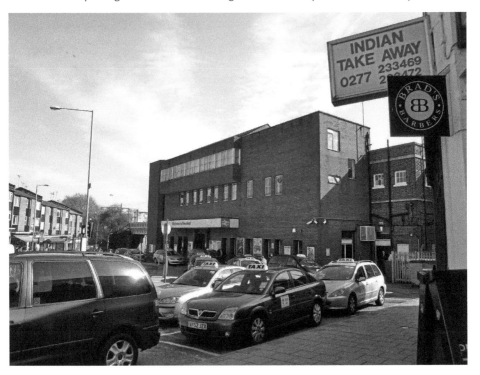

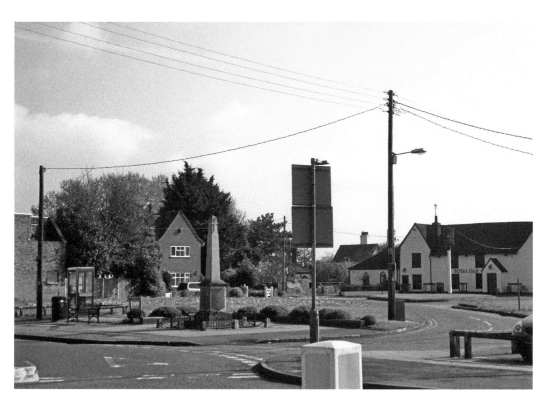

South Ockendon, The Village Green

The village green has changed little from the old photograph apart from the building to the left, which seems to have been replaced with a more modern house. Unfortunately the photographs do not show the church to the right which has an unusual round tower.

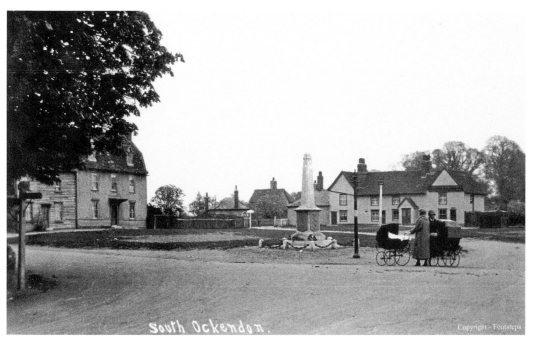

South Ockendon.

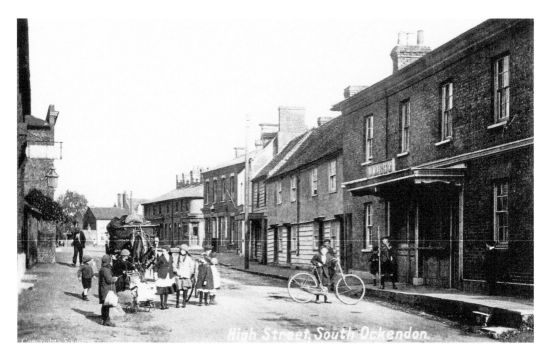

South Ockendon, High Street

The Old Village High Street has changed dramatically. Although a few old buildings remain on the north side of the street, the other side has been replaced by the new estates, which have turned South Ockendon from a small village to a much larger modern town.

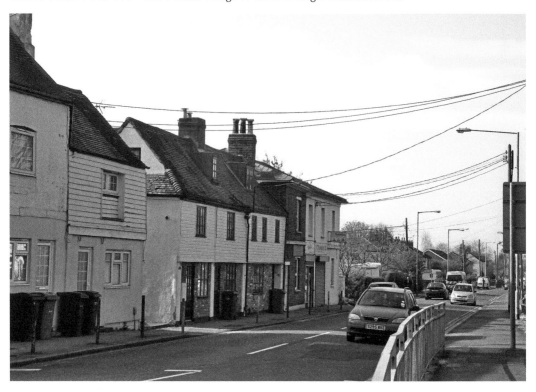

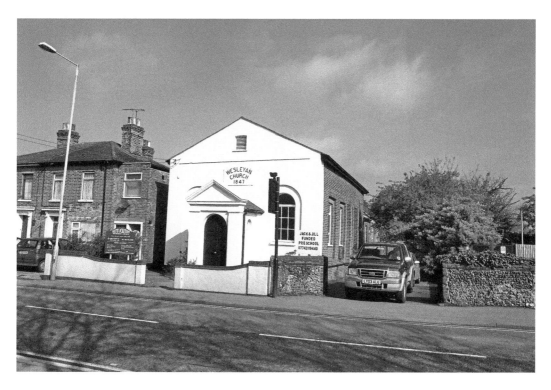

South Ockendon, The Old Chapel

The chapel was built in the mid-nineteenth century and stands in the road leading to the station from the village green. As with the Old Village High Street a number of old buildings have survived on one side of the road while new housing lines the other side. The chapel has changed little apart from a coat of paint to the front.

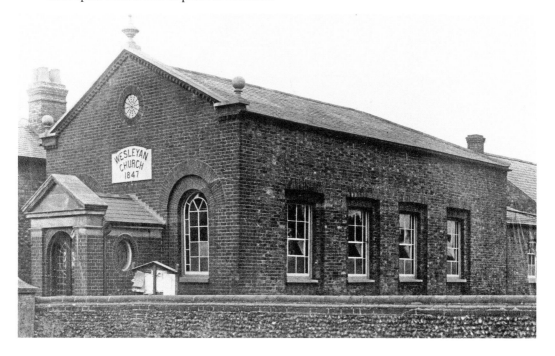

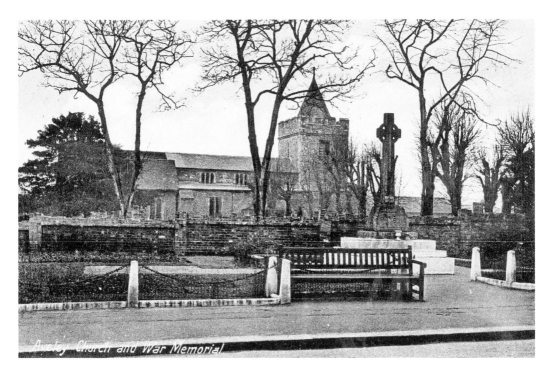

Aveley, Church and War Memorial

The church in Aveley dates from the twelfth century. In the nineteenth century it was condemned as dangerous, but locals raised the money to repair it. During the First World War a gallery was added to accommodate soldiers from Purfleet Barracks.

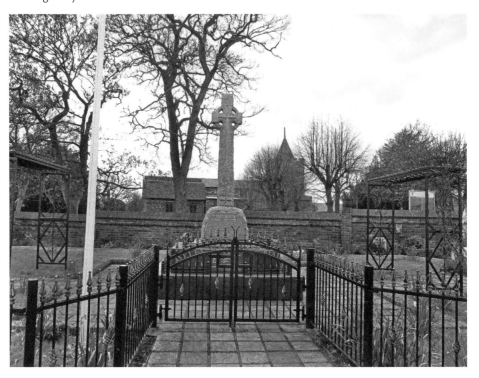

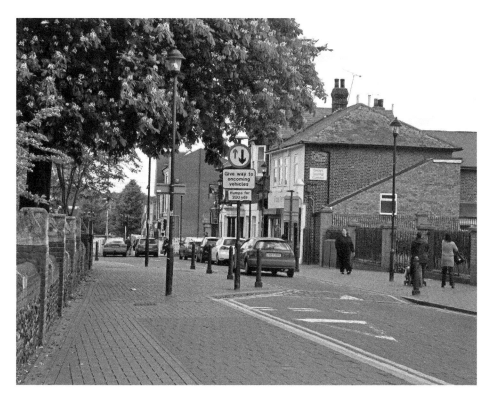

Grays, High Street

Grays is the largest town in Thurrock and the High Street has always been one of the main shopping areas. The theatre in the old image was converted into an early cinema.

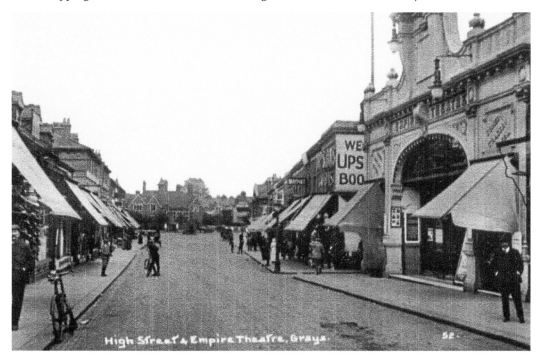

High Street & Empire Theatre, Grays.

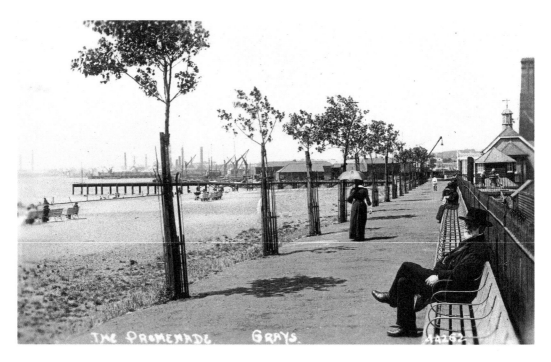

Grays, The Promenade

The area along the river has mainly been industrial. In 1906 Grays beach opened as an area for recreation by the locals. It has developed over the years into a well resourced play area for children.

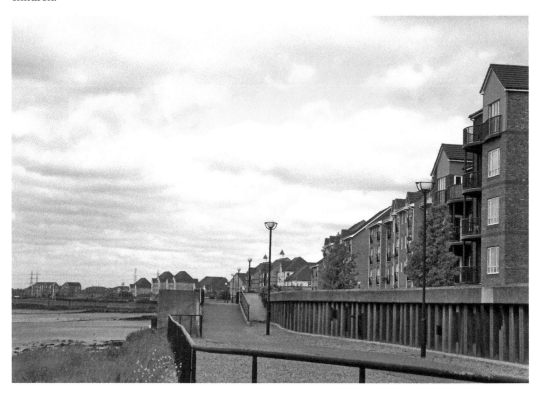

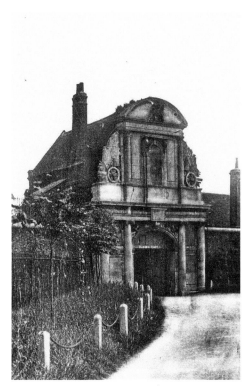

Tilbury, The Fort

The site of the fort was originally the site of a blockhouse, built in the reign of Henry VIII. It was later upgraded to a fort by Charles II. Work began in 1670 and it became one of the main defenses on the Thames. During the nineteenth century other defenses were built nearer the coast and Tilbury became almost redundant. This was one of the reasons it survived in its ancient state as it was not upgraded.

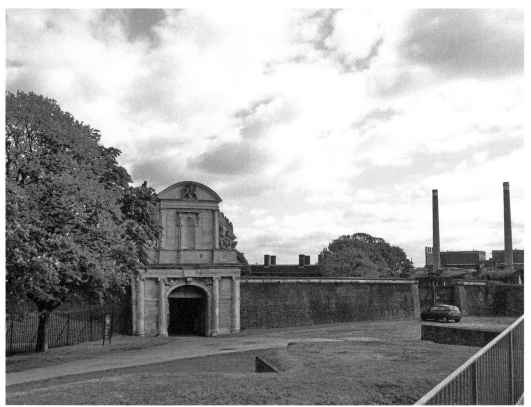

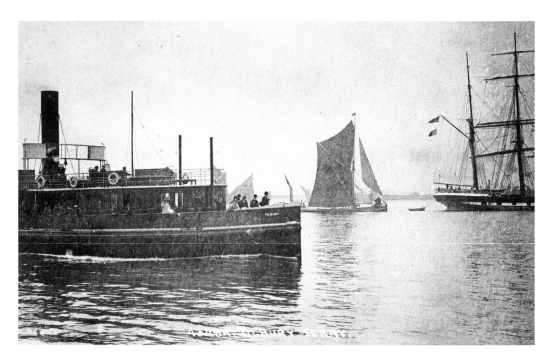

Tilbury, The Ferry

The ferry dates back to the middle ages. It was an important point of contact between Tilbury Fort and the defences on the Kent side of the river in the more recent past. The ferry did for a while carry cars from the late 1920s until the Dartford Tunnel opened in the mid 1960s. It now runs Monday to Saturday.

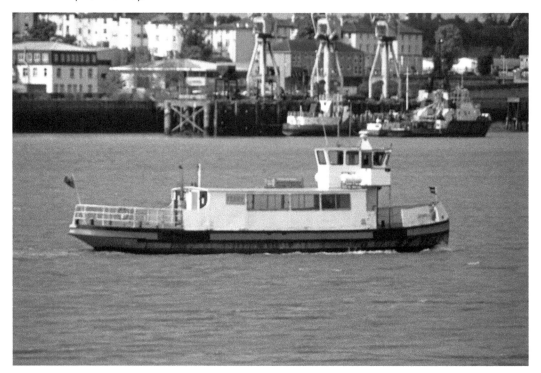

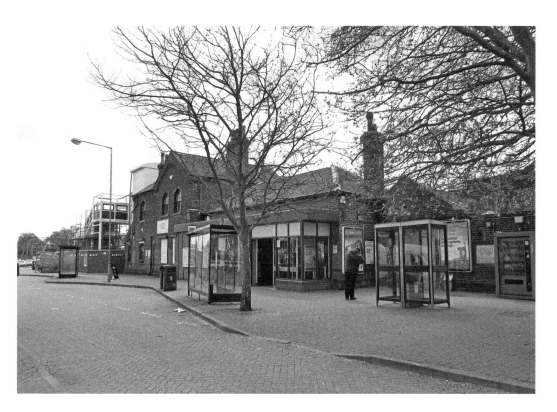

Laindon, The Station

The station at Laindon opened in 1888 by the London, Tilbury & Southend Line. At the time, Laindon was little more than a village. It has now been taken over by the post-war spread of Basildon.

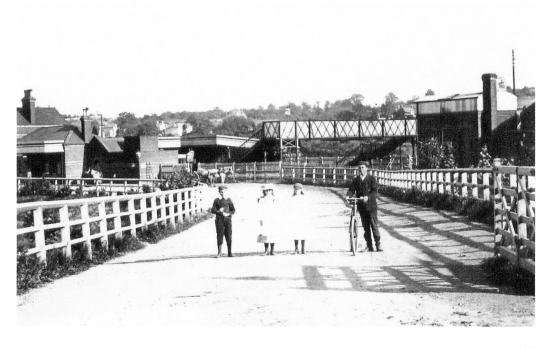

Basildon, The Town

In the early twentieth century Basildon was a small village. Large areas around it were sold off in small plots to people who built their own homes, often from whatever materials they could get hold of. After the war it was decided a new town would be built. As Basildon was the most central of the villages that this would encompass, its name was chosen for the town.

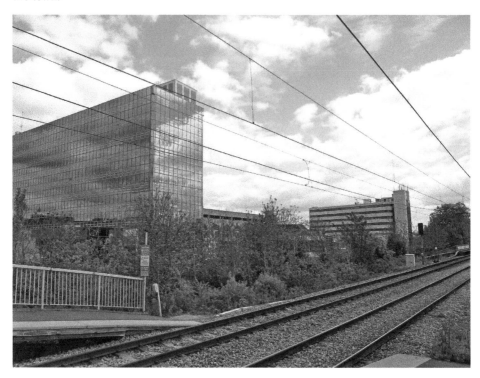

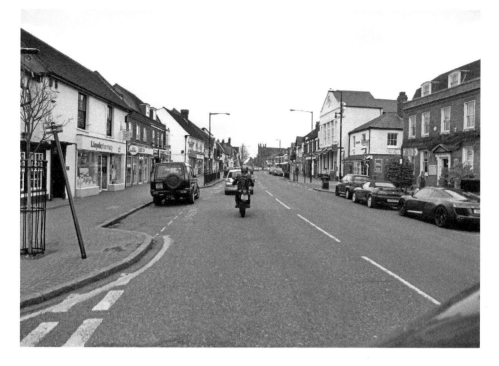

Billericay, High Street

The site of the present day Billericay has connections with the Bronze Age and the Romans. The supposed reason for the number of pubs in the town was that it lay on the pilgrim route to Canterbury. There have been some conflicts in the area and it is supposedly where the Peasants' Revolt of 1381 ended with a battle between rebels and Richard II. In the First World War a zeppelin was shot down and just missed crashing in the High Street. There are a number of old buildings still standing in the High Street.

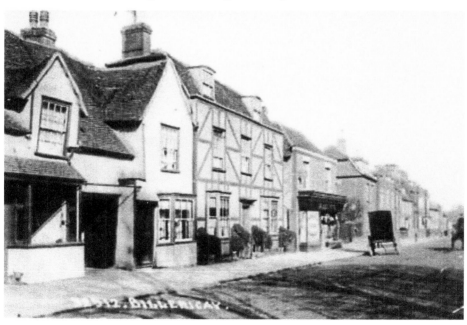

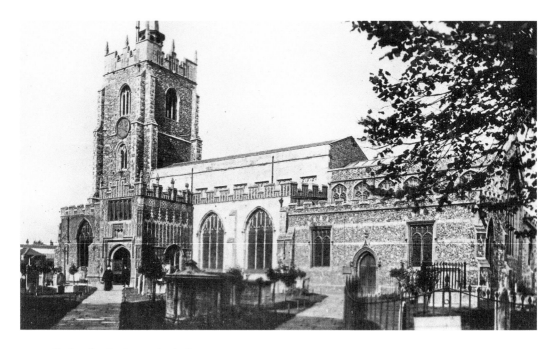

Chelmsford, The Cathedral

The church of the Virgin St Mary was just a parish church until 1914 when it became the seat of the bishop of Chelmsford. It is one of the most recent cathedrals in the country. The original church is about 800 years old with adaptations from later periods. In 1953 the south porch was extended and a window commemorates the American airmen who were based in the area during the Second World War.

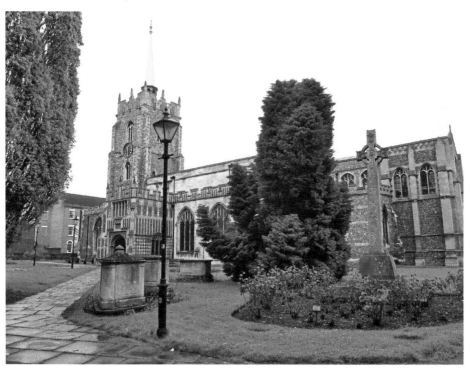

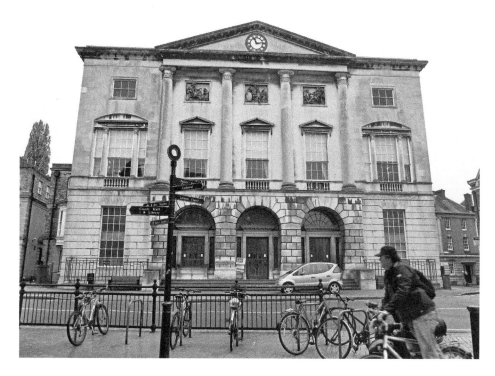

Chelmsford, The Shire Hall

The site of the Shire Hall was that of a sixteenth-century session house where over 200 trials of witches took place under Matthew Hopkins the 'Witchfinder General'. The hall was built in 1791 as a courthouse. It continued to be used as a court until 2012 when a new magistrates' court was built.

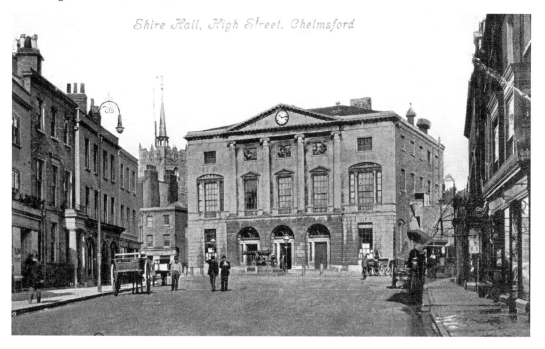

Shire Hall, High Street, Chelmsford

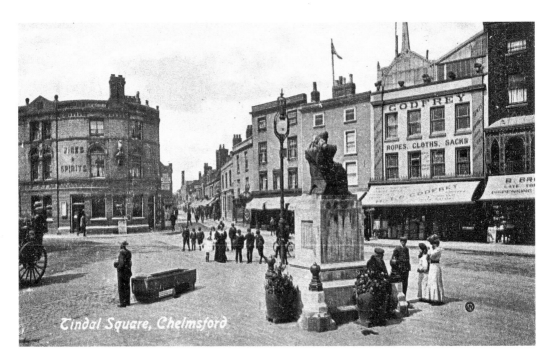

Chelmsford, Tindal Square

Tindal Square is named after the man whose statue dominates the space. Sir Nicholas Conyngham Tindal 1776–1846 was the lawyer who defended Queen Caroline in 1820 when she was accused of adultery. Tindal was born in Chelmsford and his statue was erected in 1850.

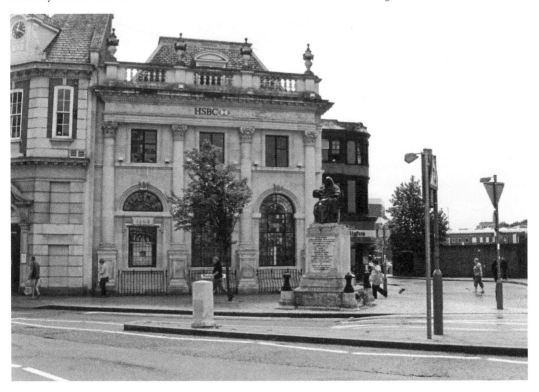

Chelmsford, The Stone Bridge

The Stone Bridge at the end of the High Street was designed by John Johnson, the man who built the Shire Hall in 1787. As the old image shows, the bridge was then part of a roadway. The area is now fully pedestrianised.

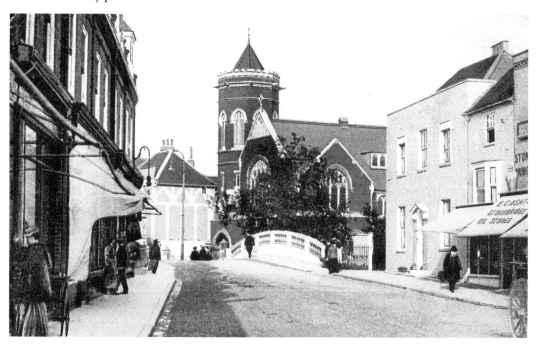

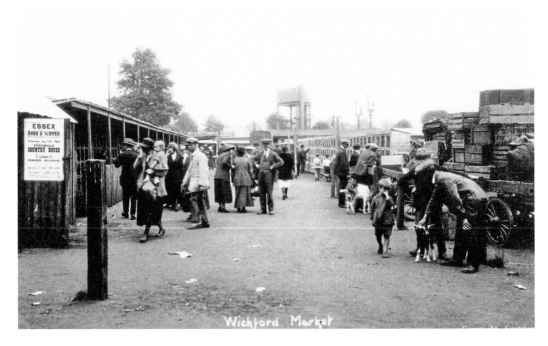

Wickford, The Market

Plans for the market were included in the plans to redevelop large parts of the town. One aim was the building of shops with flats above, around the market place area, as can be seen from the modern photograph.

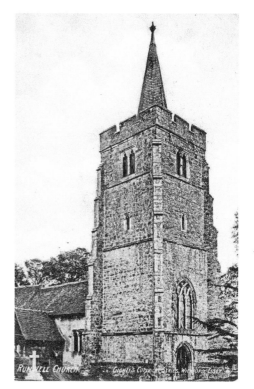

Runwell, St Mary's Church

Runwell was a small village close to Wickford, but the two areas have become closer together as building has spread along the road towards the village. The church of St Mary's dates to the fourteenth century, although there are some thirteenth-century parts, and there was a church stood in the village much earlier.

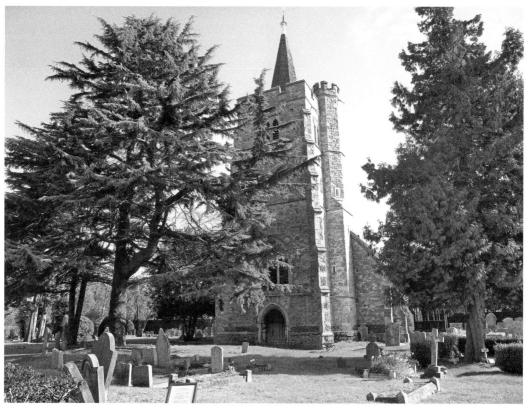

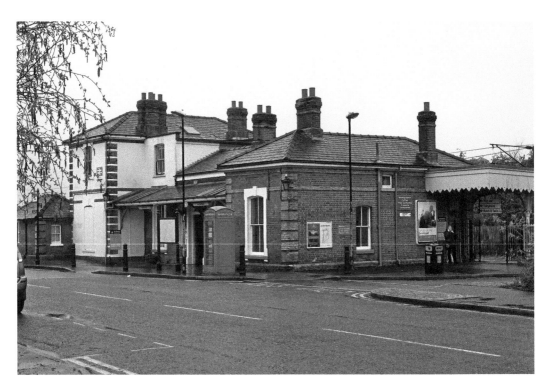

Braintree, The Station

The first station opened in Braintree in 1848. It closed when a new line to Bishop Stortford opened in 1869 and the present station opened. Through trains stopped running through the station in 1952. It is now the final stop on the Witham to Braintree branch line.

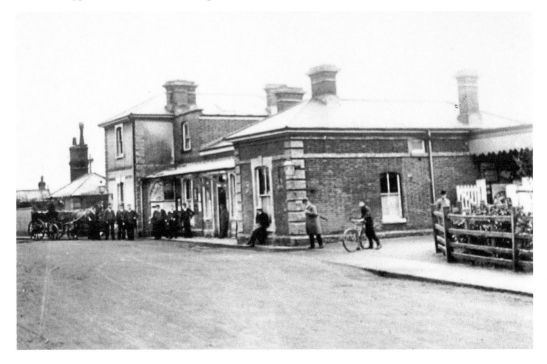

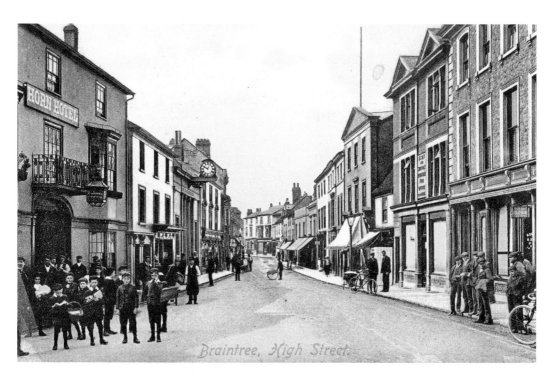

Braintree, High Street

Braintree, High Street
The High Street seems to have changed little since the old photograph was taken. It is only the use of the buildings that has altered. The Horn Hotel to the left of the old image is now shops. The street seems even narrower in the modern photograph and the roadway is cobbled.

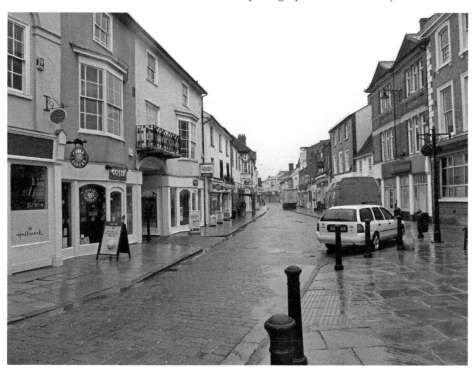

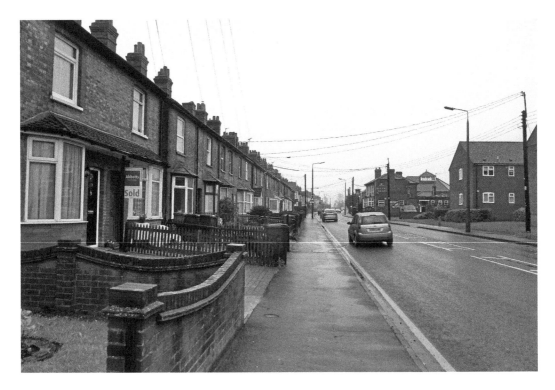

Braintree, Rayne Road

Many towns in Essex were full of soldiers in the First World War. Many of them were billeted in people's homes. The old postcard was from a soldier who was billeted one of the houses in the card. Unfortunately he did not note the door number. The houses on the left of the new image are very similar.

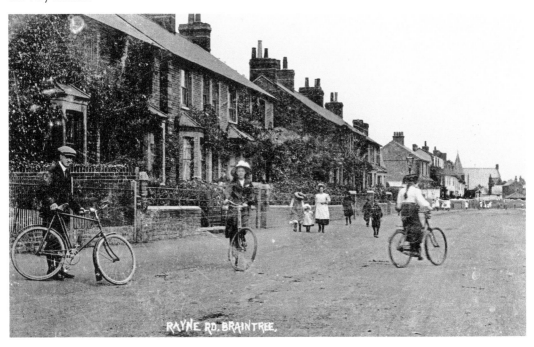

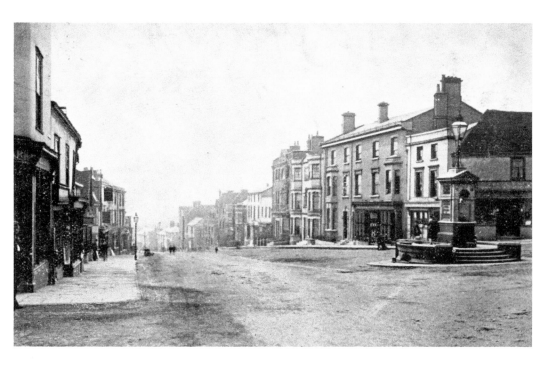

Halstead, High Street

The town of Halstead is situated on a hill north of Colne River in Colne Valley. From the top of the High Street there is a view across the surrounding countryside. The town was often used for the site of filming of the *Lovejoy* programme starring Ian Macshane.

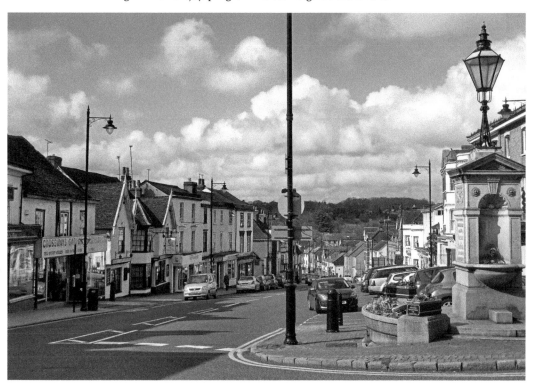

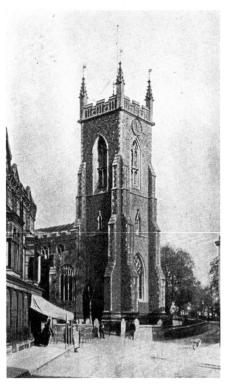

Halstead, St Andrews Church

The Church in Halstead dates from the fourteenth century. It was widely renovated during the Victorian period. There are still tomb monuments from the fourteenth century.

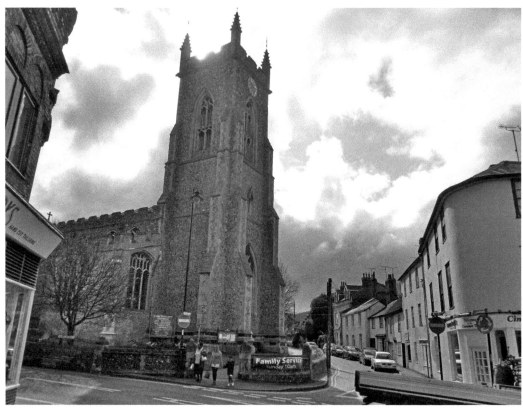

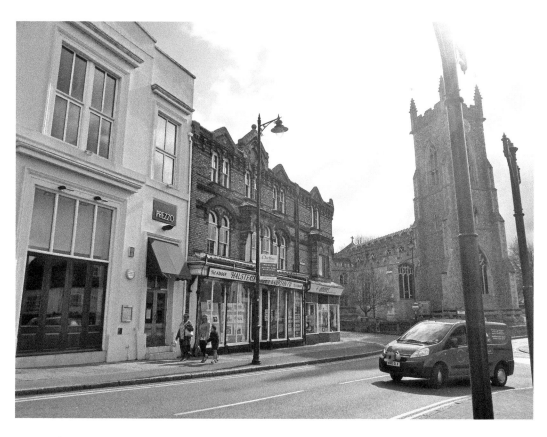

Halstead, Market Hill

The town has had a market since Saxon times. Market Hill has a number of old buildings that have survived. It stands at the beginning of the High Street opposite St Andrew's Church.

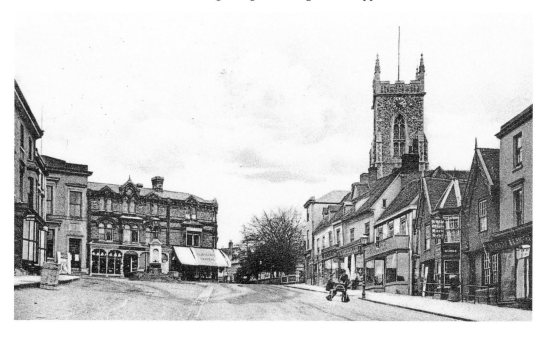

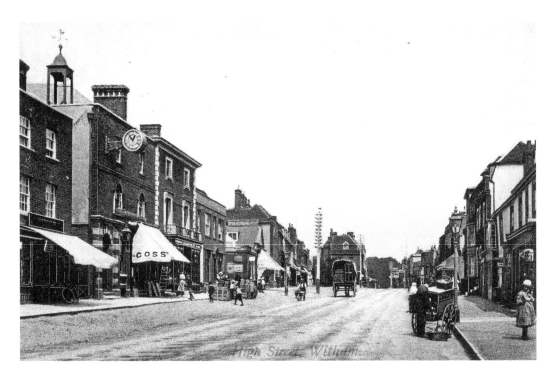

Witham, High Street

It is interesting that both the old images of Witham are entitled High Street. There is no High Street as such and the street shown is called Newlands Road. There are other old cards that do call it Newlands Road so there does not seem to have been a change of name. There are a number of old buildings in the street and part of it has been designated as a conservation area.

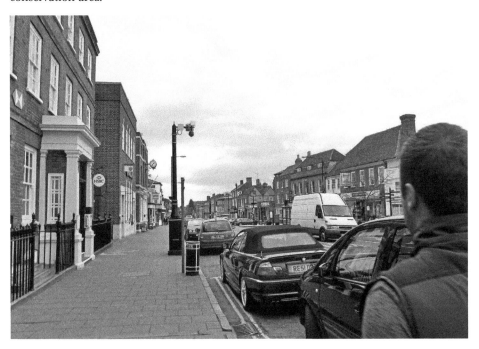

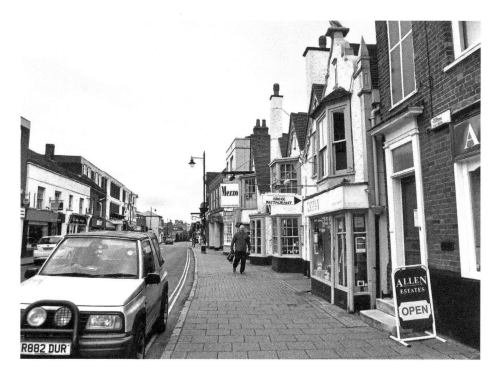

Witham, The Spread Eagle

There was an inn on the site of the old Spread Eagle in Newlands Street dating back to the thirteenth century. The present building dates back to the sixteenth century. It is now called Elements but the old name of the Spread Eagle is still mentioned on the bottom of the sign.

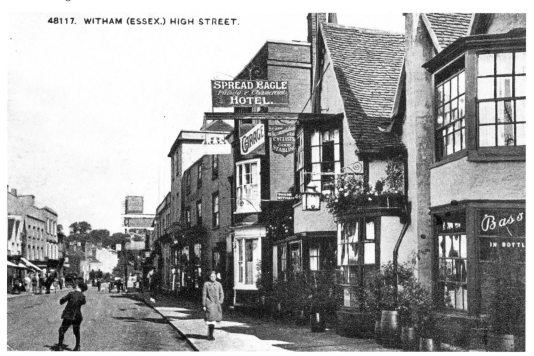

48117. WITHAM (ESSEX.) HIGH STREET.

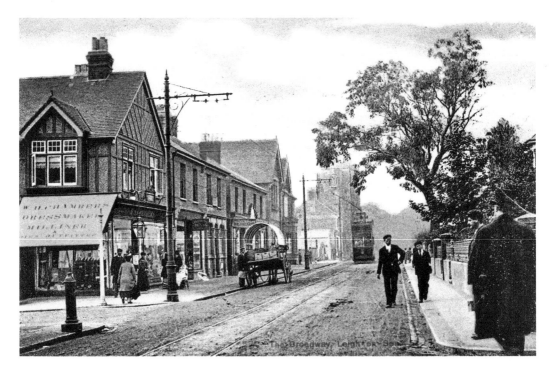

Leigh On Sea, High Street

The old image shows the shops that stood in the High Street at the turn of the twentieth century. The tower of the church is just visible in the centre with a tram passing it. The modern photograph shows how much the street has changed since then.

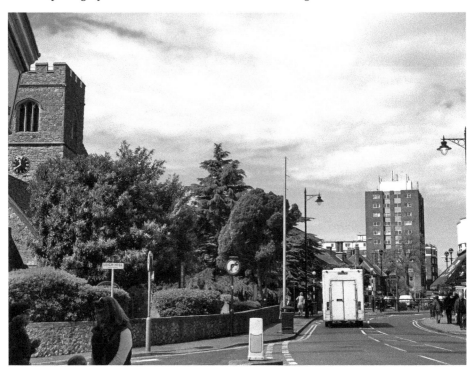

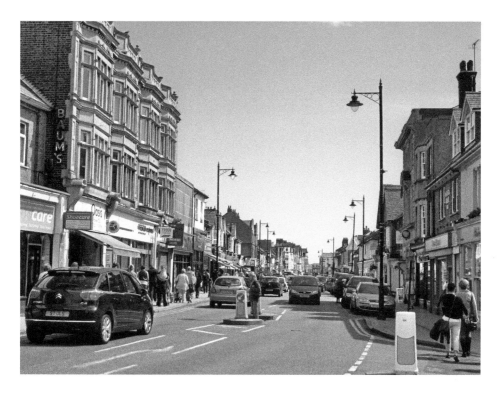

Leigh On Sea, High Street

There is little doubt that some of the buildings that stand in the High Street date back as far as the period when the old image was taken. No doubt what is being sold in the shops now is very different to what it was then.

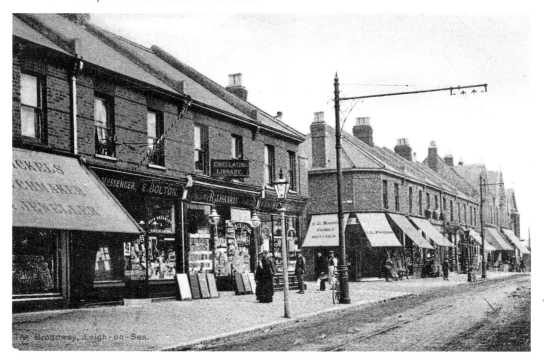

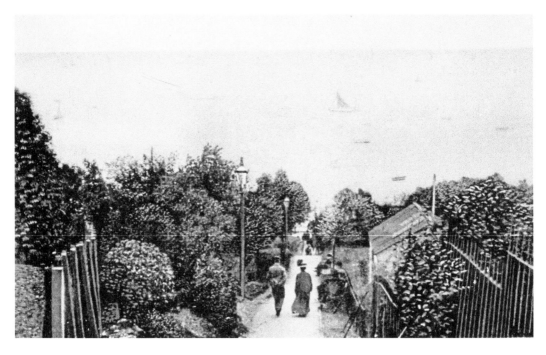

Westcliff, The Steps

The beach at Westcliff is much lower than the level of the town itself. There are a series of steps along the cliffs leading down to the beach level. The steps in the modern photograph stand at the end of Holland Road.

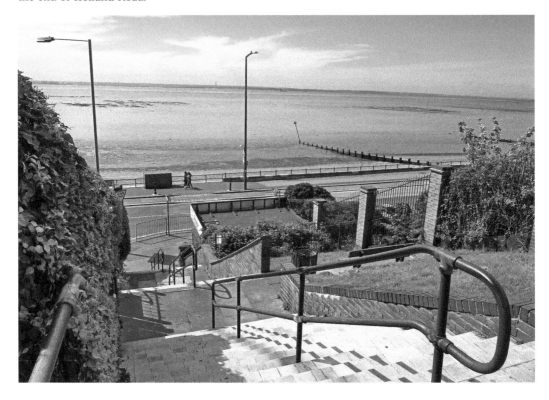

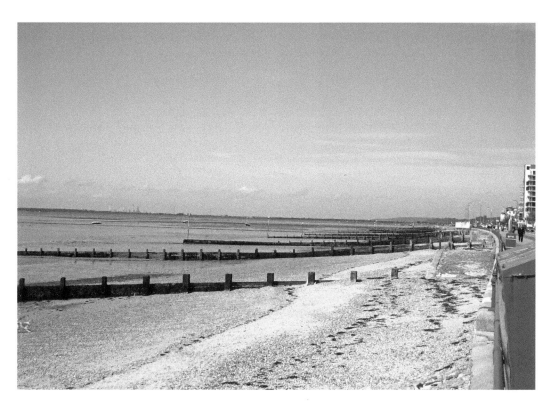

Westcliff, The Beach

The old photograph of the beach shows some interesting bathing machines and deckchair hire, three hours for a penny. The nurse in the photograph is named on the rear of the card as Nurse Pachin. It seems that she was the nurse for a baby boy. The modern image shows a less crowded beach.

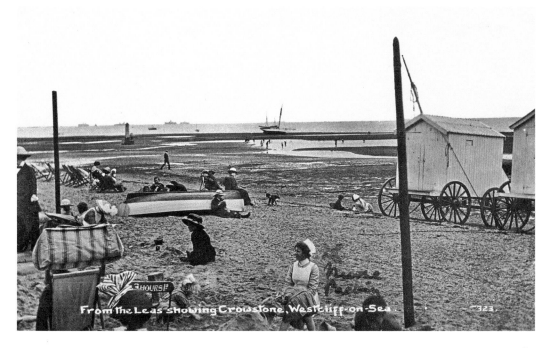

From the Leas showing Crowstone, Westcliff-on-Sea.

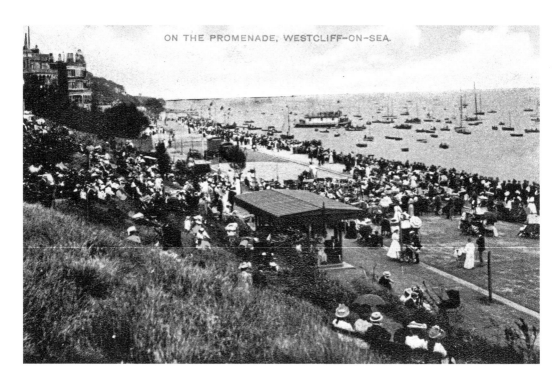

Westcliff, The Promenade

It seems that Westcliff was a much more popular seaside resort in the past than it is today. Most of the people there seem to now be on their way along the coast to Southend. The modern image shows one of Westcliff's main attractions today, the Cliff's Pavilion.

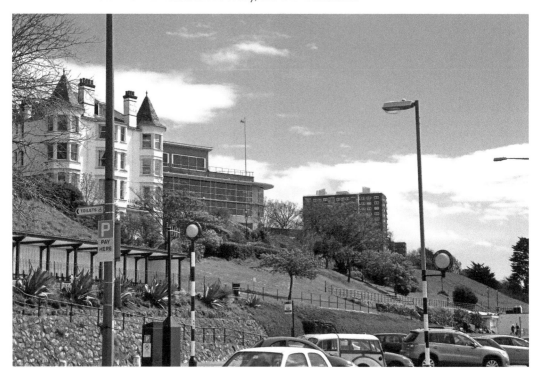

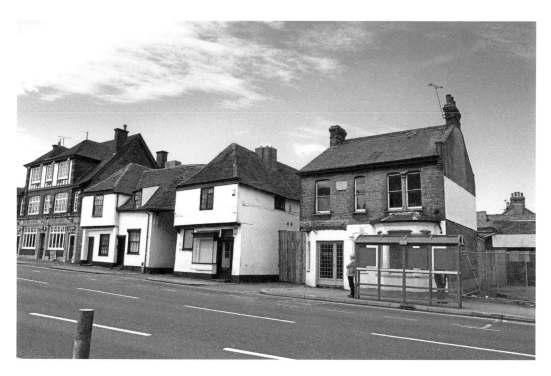

Prittlewell, The Village

The village of Prittlewell was the original site of what is now known as Southend. This was the south end of Prittlewell. The village was mainly based around the site where East and West Streets and Victoria Avenue meet. In 2003 a seventh-century Saxon tomb was found in Prittlewell with a great deal of valuable artifacts.

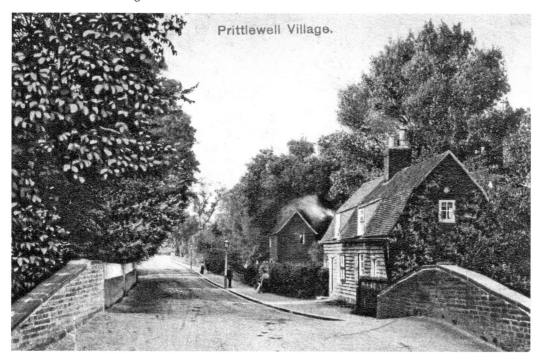

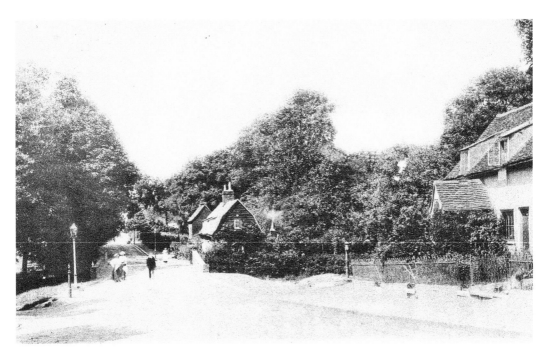

Prittlewell, The Village

The village was centered around the church of St Mary's, which is now opposite some of the old buildings that have survived. The one shown in the modern photograph is thought to have once been the market hall. It is now an estate agent called Tudor Estates.

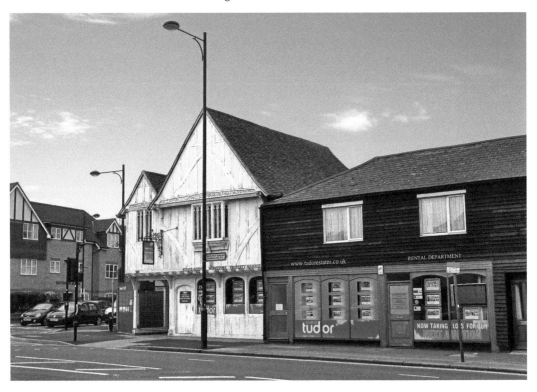

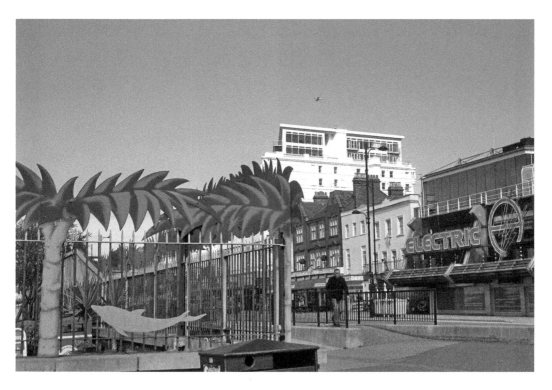

Southend, The Palace Hotel

There is a great deal of difference between the old view and the modern view of the Palace Hotel. The old image was probably taken not long after it was built in 1904. The hotel itself has been renovated and another floor has been added. The beach from where the old image was taken is now covered in a fairground.

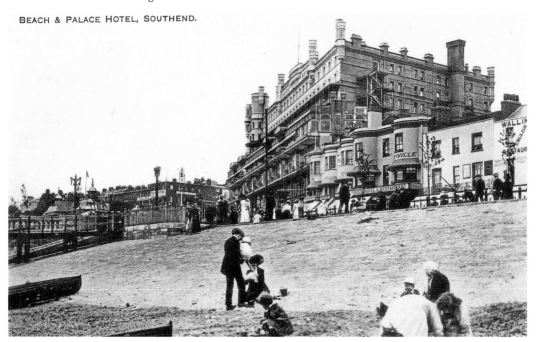

BEACH & PALACE HOTEL, SOUTHEND.

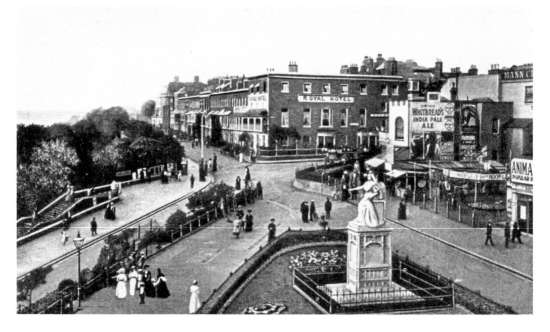

Southend, Pier Hill

Although the Royal Hotel appears in both photographs, little else has remained the same on Pier Hill. The statue of Queen Victoria was presented by the Mayor Bernard Willshire Tolhurst in 1897 to mark the Queen's Diamond Jubilee. It stood on the hill until 1962, supposedly pointing to the gents' toilets. It was then moved to Clifftown Parade.

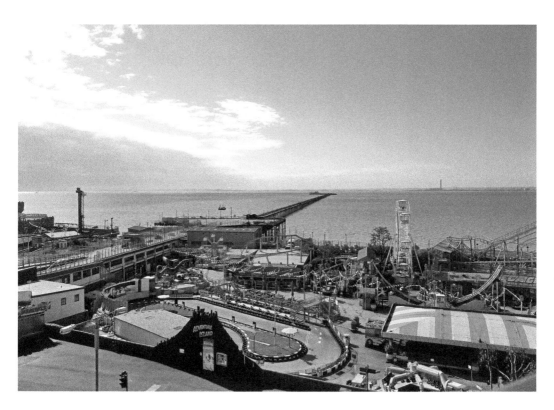

Southend, The Pier

Despite being a popular resort in the nineteenth century, Southend lost out on boats bringing visitors because they could not land due to the shallow water over the mudflats. A pier was built in 1830 to solve this problem but at 600 feet it was still not able to be used at low tide. By 1848 it was extended to 7,000 feet, the longest pier in Europe.

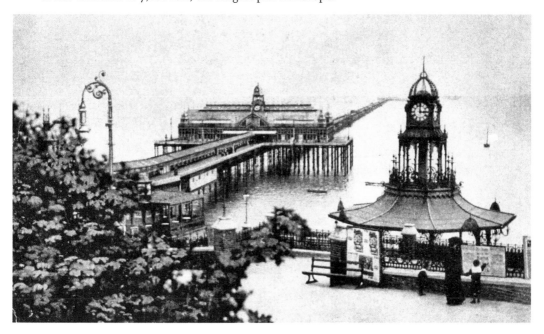

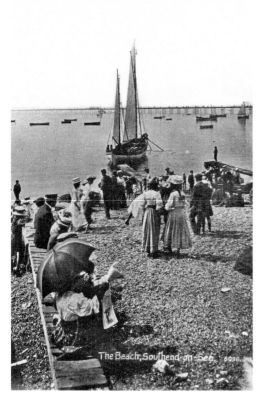

Southend, The Beach

The beach at Southend has obviously been very popular for many years. What is worn on the beach has changed. Those visitors in the old image would no doubt have been shocked to see women in bikinis. However the weather had kept most people off the beach in the modern photograph.

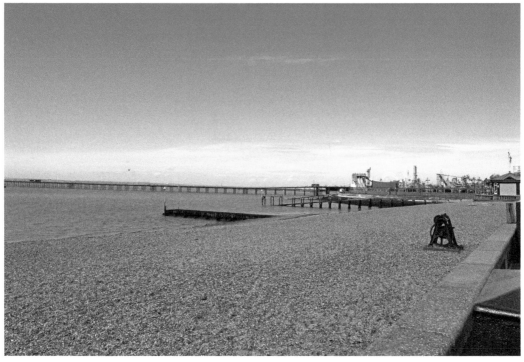

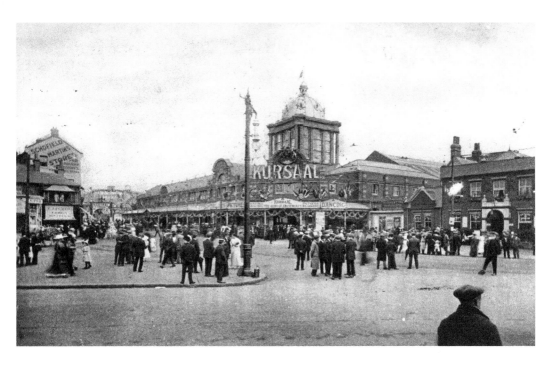

Southend, The Kursaal

The Kursaal was built in 1901 as part of a Marine Park and Gardens. The Kursaal was the amusement part of the complex. It was the world's first theme park and has had a number of different attractions over its lifetime. It closed in the 1970s and was almost derelict before the Kursaal building itself reopened in 1998.

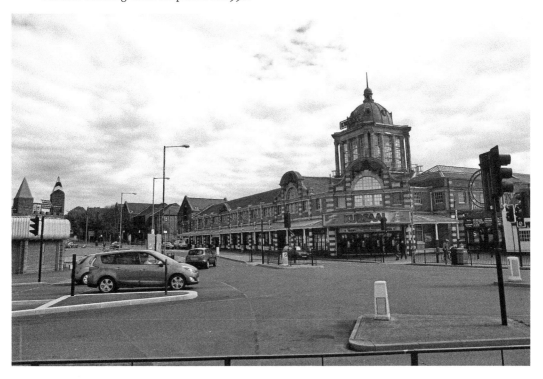

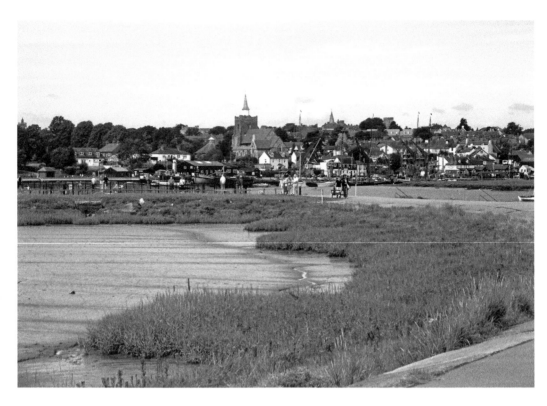

Maldon, The Town From The River Blackwater

The town of Maldon is known as the site of a famous battle between the Saxons and the Vikings. There is a statue to the Saxon leader Byrhtnoth by the river. Although he lost the battle he was very sporting in letting the Vikings cross a causeway before fighting them.

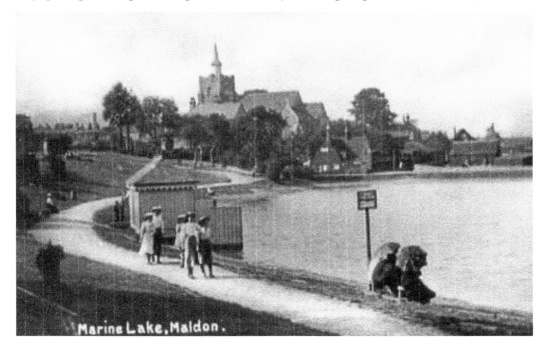

Marine Lake, Maldon.

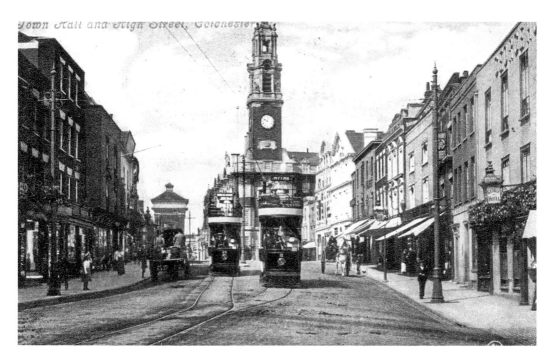

Colchester, The High Street

Colchester is claimed to be the oldest town in Britain. It lives up to its name with numerous old buildings. Every street you turn into seems to hold another ancient building. Although the buildings in the High Street have changed little between the old and new image, the vehicles using the road have.

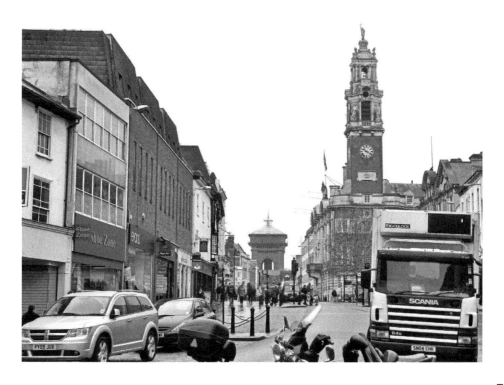

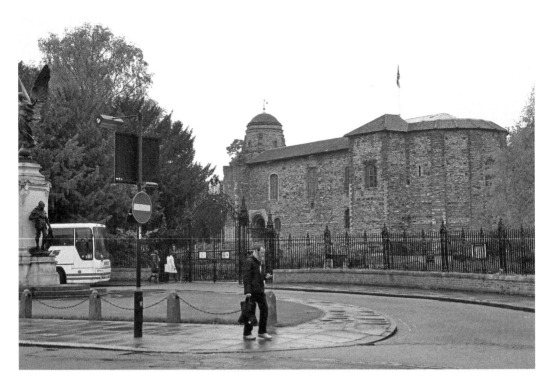

Colchester, The Castle

The Castle in Colchester dates back to Norman times. There are a number of Roman bricks and tiles used in its construction and it stands on Roman ruins. It has been used as a prison and an air raid shelter at different periods of its history. It is now a museum.

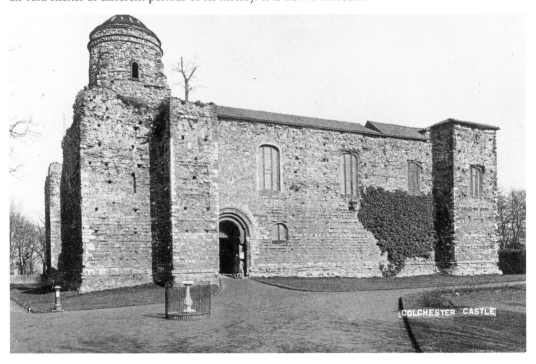

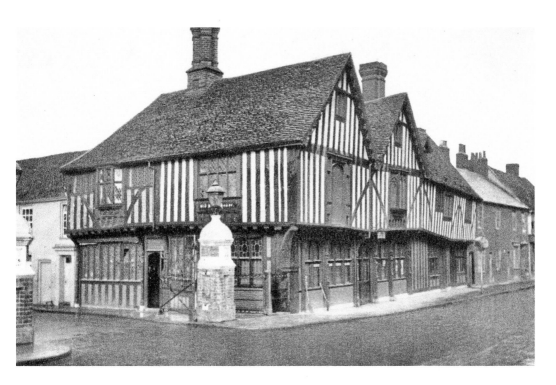

Colchester, The Siege House

The Siege House dates back to the fifteenth century. It stands by the bridge, which crossed the river that surrounded the town and castle. It was here on East Hill and East Bridge that much of the fighting took place during the siege of the town in 1648. The side of the building still bears bullet holes from the siege. The building is now a restaurant.

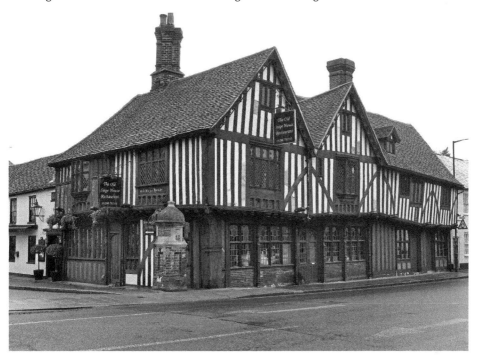

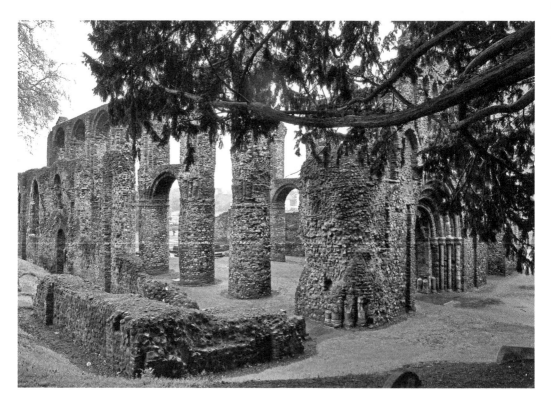

Colchester, St Boltoph's Priory

The Priory dates from the eleventh century. It then became the mother church in England of the Augustan Order around 1200. After the Dissolution of the Monasteries the Priory church became the local parish church. This was then destroyed during the siege of 1648.

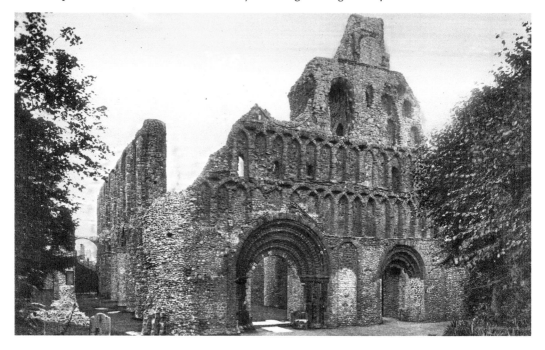

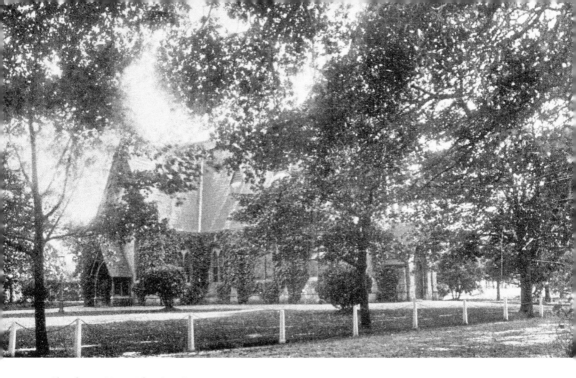

Shoebury Ness, The Garrison

The Garrison Chapel based on the Shoebury Barracks and served those based there throughout both World Wars. The barracks have now closed and have been converted to a private housing estate, with the chapel being used as the sales office.

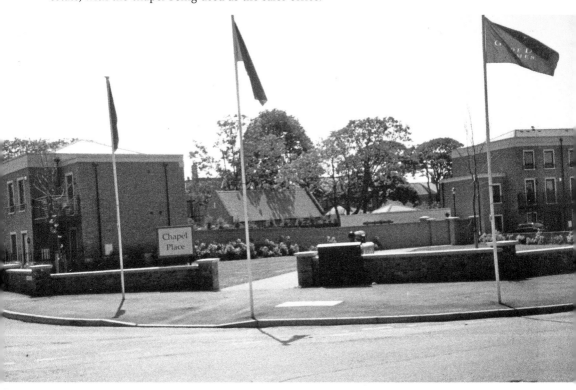

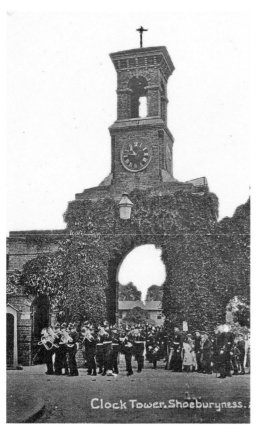

Shoebury Ness, The Garrison
The Clock Tower stands inside the barracks and leads to the parade ground and barracks. The tower has survived the closure of the barracks and the parade ground is now an open area surrounded by private homes.

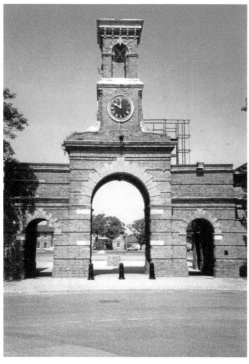

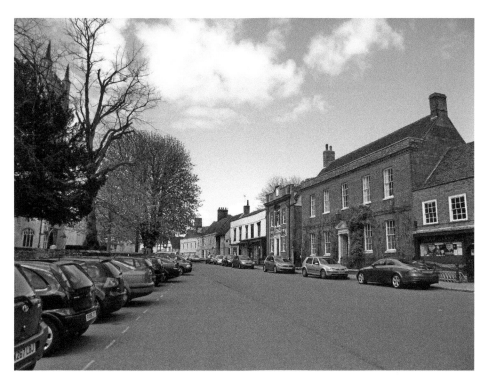

Dedham

Dedham stands on the River Stour close to the border with Suffolk. It is best known as Constable Country where Constable lived, went to school and painted. Much of the area still looks the same as when the old photograph was taken.

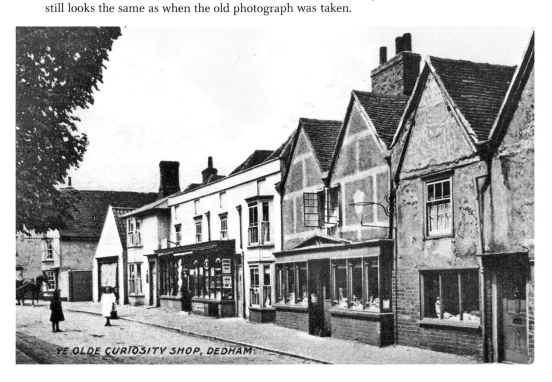

YE OLDE CURIOSITY SHOP, DEDHAM.

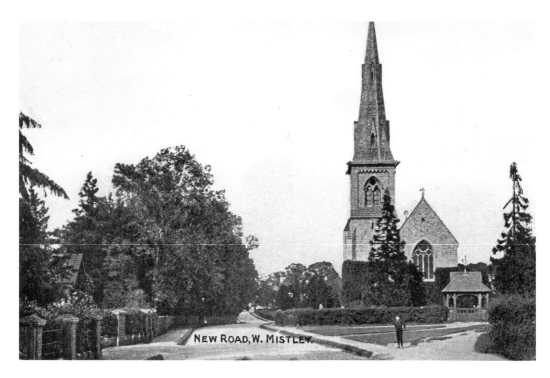

Mistley, St Mary's Church

Mistley is a village so close to Manningtree that the two are almost indistinguishable. It is best known for its nuclear bunker built in 1951 and the still standing towers of St Mary's church demolished in 1870. The church in the old image is St Mary's and St Michael's built to replace the old church.

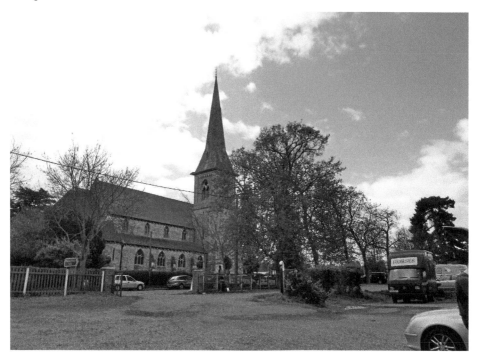

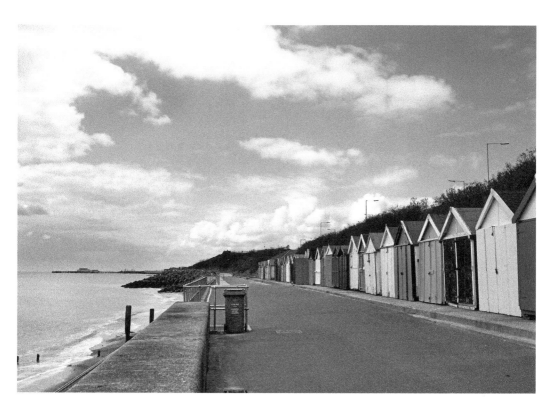

Holland on Sea, The Cliffs

The cliffs at Holland were quite bare in the old image. During the war, a number of pillboxes and defenses were built along the cliffs. Erosion led to many of these sliding down onto the beach. Today the cliffs are lined with beach huts and concrete walkways.

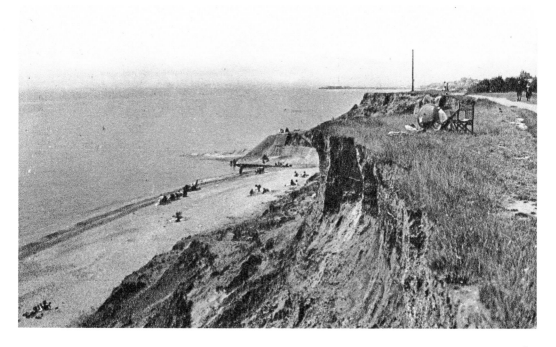

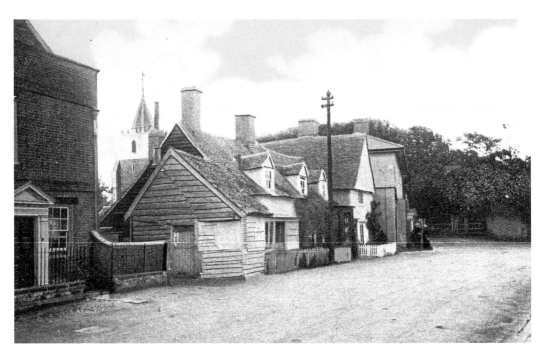

Great Clacton, The Village

Great Clacton is one of the villages that have been swallowed up in what is now known as Clacton Upon Sea. Although surrounded by the expansion of modern Clacton, Great Clacton still retains its old image of a village in one small area.

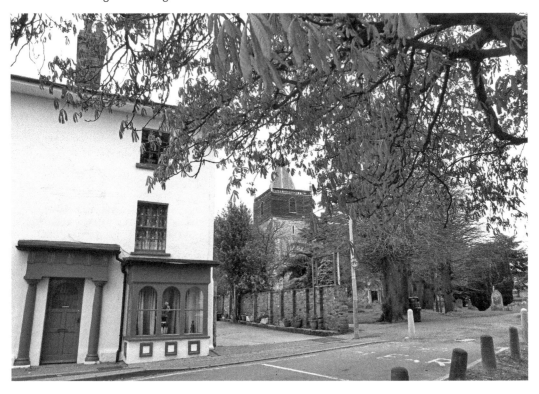

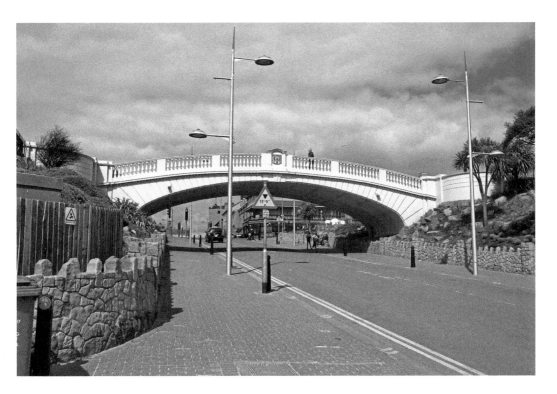

Clacton, The Pier

The pier opened in 1871 and was 150 metres long. It was used as a landing stage for passenger steamships. In 1893 it was extended to 360 metres and a pavilion was built. Amusements such as a theatre were built after the First World War. Little has changed in Pier Approach from the old image to the modern one.

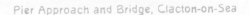

Pier Approach and Bridge, Clacton-on-Sea

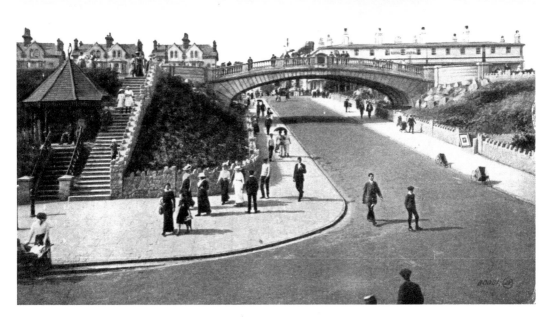

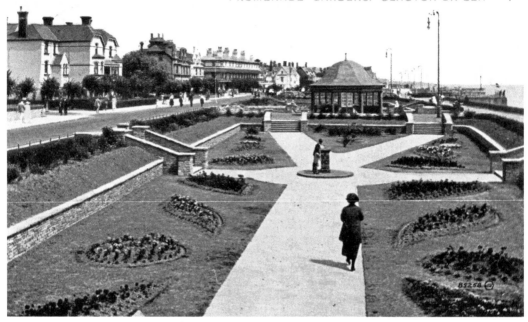

Clacton, The Promenade Gardens

The Promenade Gardens line the beach with colourful flower beds. They are also the site of the town's war memorial. There are a number of benches where visitors can sit away from the crowds at the more popular sites.

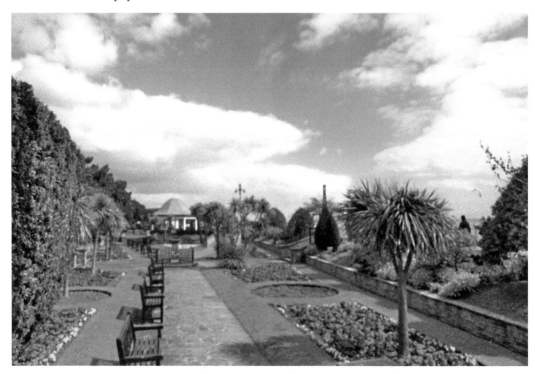

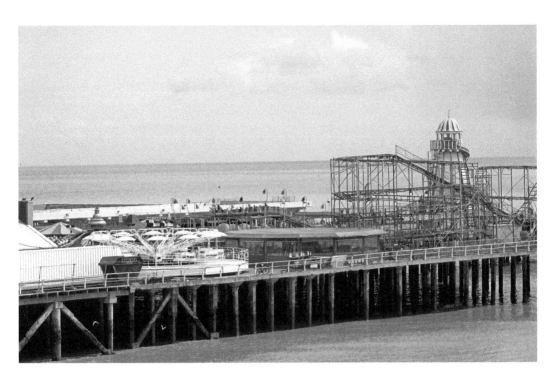

Clacton, Amusements

The types of amusements that attract holidaymakers to the seaside today have changed greatly. The Japanese Pagoda may have been popular before the First World War. Today's holidaymakers are seeking greater thrills such as those on the pier rides.

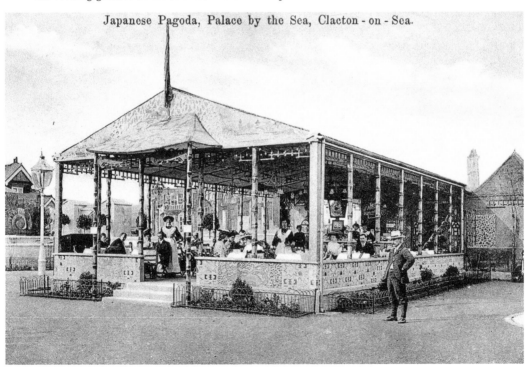

Japanese Pagoda, Palace by the Sea, Clacton - on - Sea.

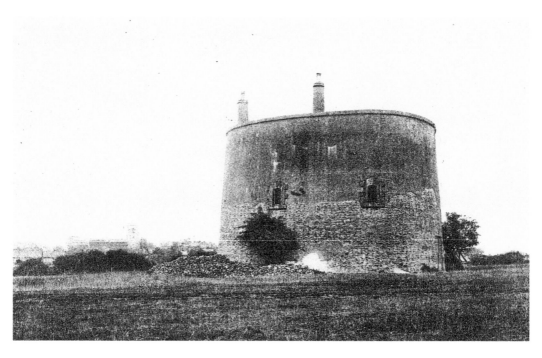

Walton on Naze, The Martello Tower

Walton is the site of a surviving Martello tower from the Napoleonic War. It is now surrounded by a caravan site called the Martello Site. Although once used as a bar, it is now unused.

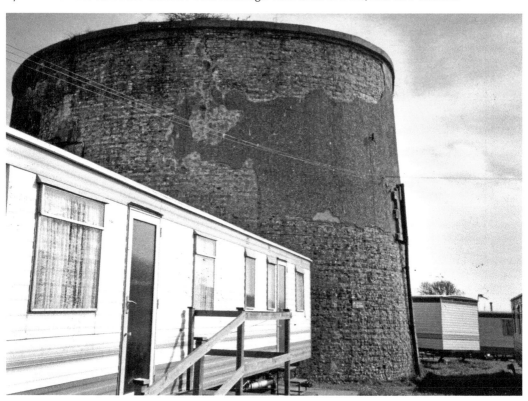

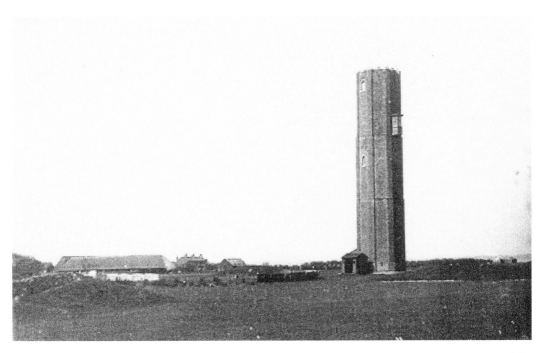

Walton on Naze, The Tower

The Naze Tower was built in 1720 and is 86 feet high. It was built as a landmark for ships. During the Second World War it was used as a radar tower. A number of pillboxes still line the beach, which have fallen from the cliffs due to erosion that now threatens the tower.

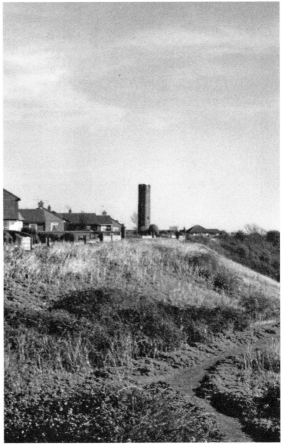

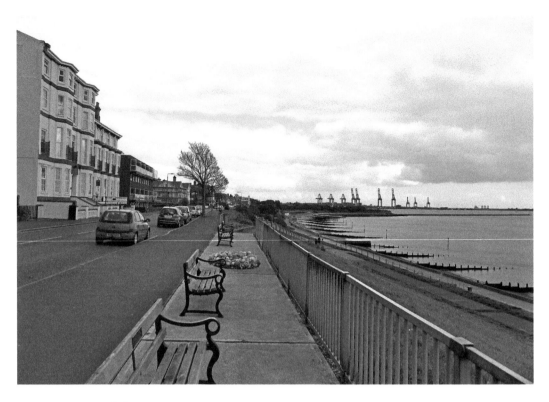

Dovercourt, The Cliffs

Dovercourt was once a separate town from nearby Harwich, but there is no clear difference between them now. Dovercourt developed as a seaside venue while its neighbour has always been a port. The cliffs are nearer to Harwich and the Cliff Hotel is visible in both images.

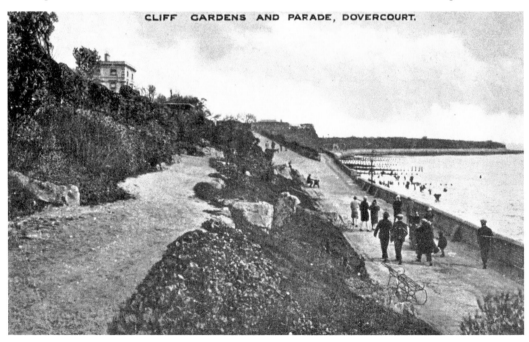

CLIFF GARDENS AND PARADE, DOVERCOURT.

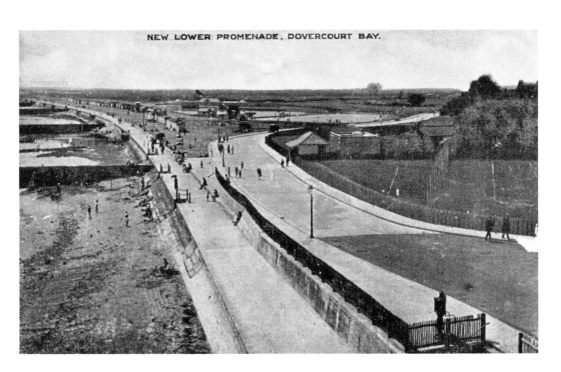

NEW LOWER PROMENADE, DOVERCOURT BAY.

Dovercourt, The Promenade
The lower promenade leads along the coast to caravan sites and what was once a Warner's Holiday Camp. Opened just before the Second World War, it became a refugee camp for Jewish children escaping Nazi Germany. It achieved greater fame as Maplin's Holiday Camp in the TV programme *Hi-de-Hi!*

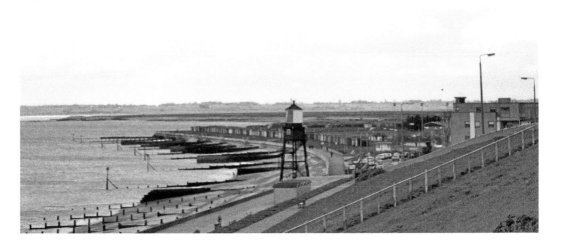

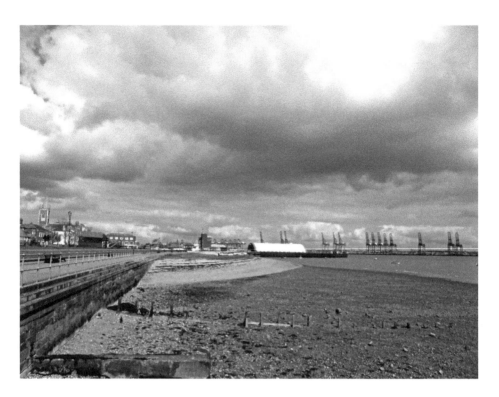

Harwich, The Promenade

Harwich has been known as a port and ship building town for many years. It is still the site of ferries crossing to Europe but they now leave from nearby Parkstone. The old photograph shows the promenade and beach. Use of the beach has been lost to nearby Dovercourt. Across the river the now extensive docks of Felixstowe are visible.

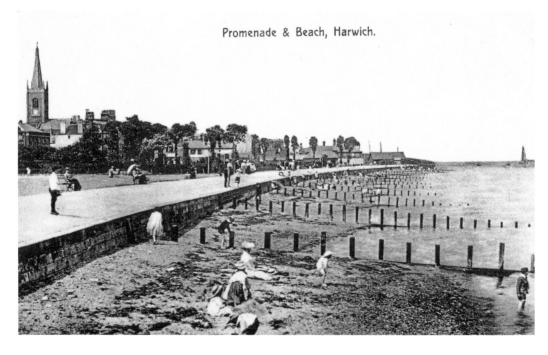

Promenade & Beach, Harwich.

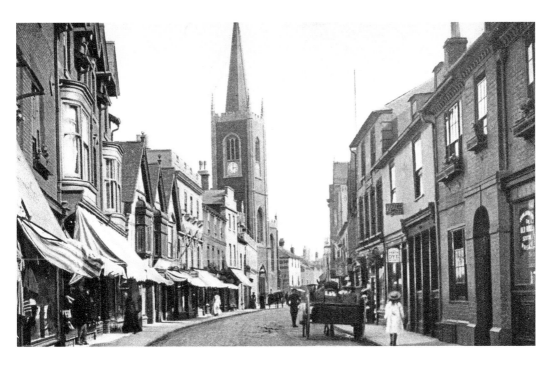

Harwich, Church Street

The town of Harwich itself has changed little over the years. Many of the buildings are very old and the streets are still narrow – Church Street is a good example. The modern image taken from the church shows that little has changed.

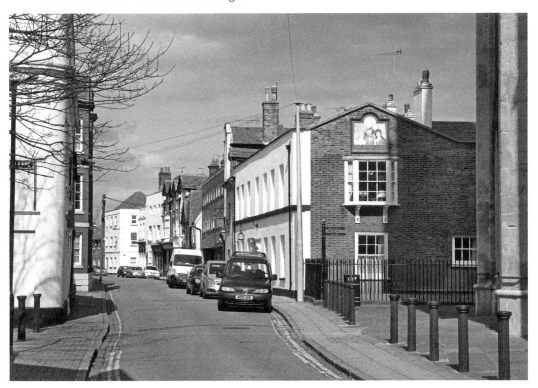

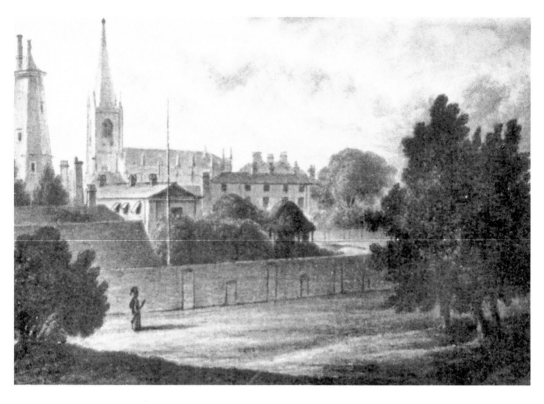

Harwich, The Town from the River
The very old image of the town from the beach shows the church and the lighthouse. As the modern image shows, little has changed in this view.